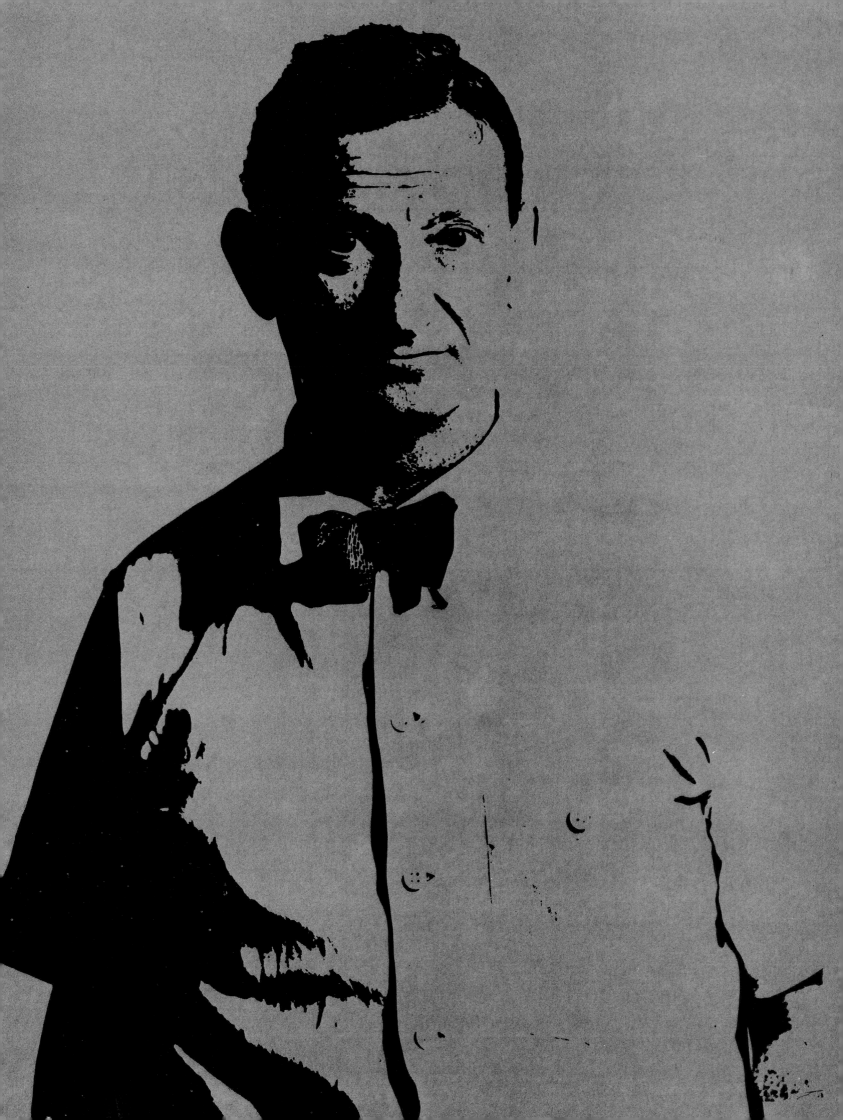

BLUMENFELD

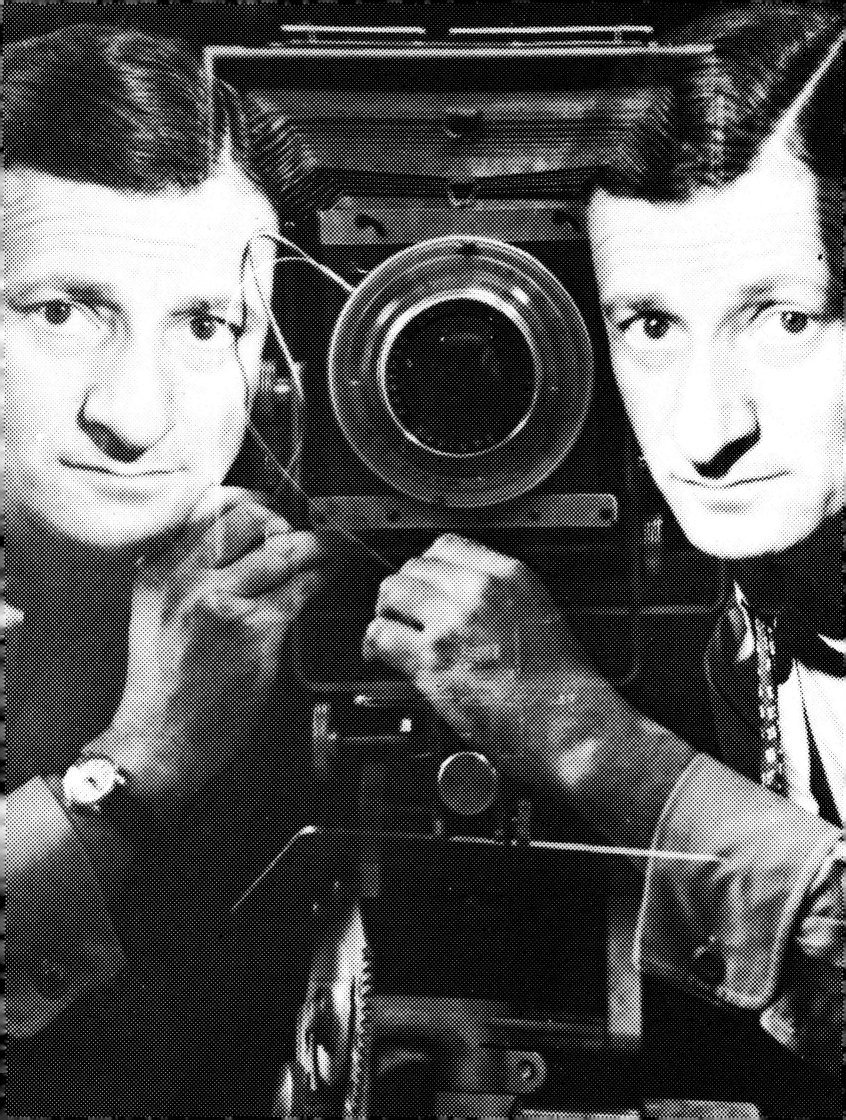

BLUMENFELD
MY ONE HUNDRED BEST PHOTOS

Text by Hendel Teicher

Translated by Philippe Garner
With Luna Carne-Ross

Introduction by Maurice Besset

RIZZOLI
NEW YORK

97,147

INTRODUCTION
by Maurice Besset

Prejudice, for so long an obstacle to the understanding of the photographer's work, has proved particularly strong against fashion photography, looked upon, until recently, as a frivolous, somewhat decadent pastime or a contemptibly mercenary pursuit. Experts in the field of the social sciences have been the first to acknowledge that promotion of the fashion industry is only an incidental facet of fashion photography and today the work of the leaders in this field is receiving due recognition as an art form—as shown by the Avedon exhibition recently held at the Metropolitan Museum of Art, New York. Nevertheless, the history of fashion photography remains fairly vague and it is as yet not fully understood that, without it, no study in depth of the contemporary image could ever claim to be complete. Such a study, however superficial, would emphasize two interrelated facts. First, the requirements of the genre are such that few photographers are able to satisfy them without, at the same time, running the risk of compromising their creative freedom and lowering the standard of their work. Second, a photographer undertaking fashion photography can only do so successfully if he has acquired in other branches—portrait, theatre, object or simply reportage photography—the knowledge and experience that will enable him to be master of camera and subject and thus retain, unimpaired, his individual approach. The work of Edwin Blumenfeld is a case in point.

It may sound contradictory to extol the freshness and simplicity of vision of work usually praised for its sophistication. The fact remains that Blumenfeld possessed both qualities to the highest degree. Far from being arbitrary or artificial, his settings are intrinsically natural, true to the essence of the subject. If, at times, he deliberately moves away from habits and convention, even goes beyond the bounds of what his contemporaries could comprehend or accept, it is never in search of originality for its own sake. Attuned, beyond the outward form, to the intricate and fluid combination of elements which determine the essence of the subject in its relation to space and time, Blumenfeld's aim is to express that essence in the most natural way. Is there a more natural and effective way of heightening the tight interweaving of fibers and characters than the acute angle of his slanting approach? The bird's eye view which shows the tower of Rouen's cathedral rising toward us from the depth like a giant polypary brings out, more clearly than any commentary ever could, the organic nature of an architecture which, from that angle, appears much more as a natural phenomenon than as the expression of some stylistic system.

Blumenfeld is fully aware that freshness of outlook need not mean neutrality, any more than an unprejudiced eye need be a blank one. He knows that the photographer's eye, like that of the painter, is far from innocent, polarized as it is by the will (of the artist) to extract an image from its contact with the subject. Honestly and logically Blumenfeld arrives at the conclusion that the truth of photography cannot be the simple, straightforward registering by the camera of some factual data. While giving a formal reproduction of the facts, it must, somehow, express their purpose and reflect, at the same time, the nature of the subject as seen through the eyes and the mind of the photographer. Enriched by this human dimension, photography, without losing any of its objectivity, acquires a density, an acuity, that no matter-of-factness, real or feigned, could ever give it.

5

Blumenfeld's shot of Maillol's most enigmatic work, *La Nuit,* tells us, with incredible candor and conciseness, more than any other shots or any commentary ever could. The exceptionally sharp vision of the artist freed from all taboos captures the true nature of the work and, at the same time, enables us to follow the mental process set off in the mind of the photographer, awakening all fantasies, guiding his choice toward a setting which expresses fully the inward withdrawal of the figure, symbol of the withdrawal of the human mind within the portentous womb of night. The striking choice of setting expresses both the essence of the subject and Blumenfeld's surprise at the discovery of such depth of darkness in the usually "sunny" work of the Mediterranean Maillol.

Other shots, with nothing in common except their unusual angle, are also proof of a patient and passionate search for meaning. When Blumenfeld chooses to show us, through the open work of the steeple, the roofs of Rouen, he sets out to compose meticulously each minilandscape framed within the pattern of the open work. The process he follows is similar to that of the medieval artist in stained glass setting his illuminated medallions in the framework of the windows or the ceiling rose of the nave. His subject is the very life of the town huddled around its church. Here again was expressed, in the simplest and most natural way, the essence of collective work, the understanding and harmony between architect and artist in stained glass which enabled them to formulate a system that simultaneously encloses space and opens it onto the outside world, separates and unites inner and outer spaces.

Between the two world wars, in the field of creative or avant-garde photography, the use of technical resources which had always been enlisted to fix, correct or clarify the image became accepted as routine procedure. The fund of technical aids, from simple retouching to the most skillful chemistry, made possible a wide field of experimental work based on the new image. Blumenfeld has never denied his use of all the laboratory resources at the photographer's disposal. But whatever the nature of his experiments, however daring and brilliant the results, contrary to the attitude of the Constructivists and of the Surrealists, he has always taken care not to tamper with the intrinsic nature of the subject or weaken its physical presence and, in so doing, destroy the effect of the psychic shock of its initial impact on the photographer's eye. It could be said that, in his quest for meaning, Blumenfeld enlisted the help of technical aids to express more clearly two complex and ostensibly contradictory facets of his art which can only exceptionally be brought out by the choice of setting. One was the more or less conscious choice made by the photographer's eye from the loose mass of perceived information which will determine the theme of the physical image, the other the simultaneous influx of associations which give it its subjective character. Retouching the raw image in shots of a bird's eye view over the roofs of Paris, for example, shows the photographer's fundamental involvement in selecting, planning the background to the image he wishes to give us of the Eiffel Tower. Shot entirely against a network of roofs forming an almost abstract grid, the image does not tell us, as did the shot of the steeple of Rouen's cathedral, how the tower was built, but how it was seen, not by Mr. Everybody, but by the Cubist painters to whom it offered a stencil for their interpretation of the landscape. By such drastic intervention *a posteriori* on the appearance of a print, Blumenfeld

ascertained the choice made by the photographer intent on giving shape to his perception of reality.

To look is not simply to choose. It is also to eliminate useless information. It is to give free rein to the imagination and to open wide the scope of the possible. From the initial image, isolated by the eye of the photographer, other images emerge which, superimposed or joined to it, slowly give it inwardness. Retouching enables the photographer to recapture the fluidity of movement of a transient image, here a second, gone the next, then reappearing, enriched by its own transcience. In one of Blumenfeld's most complex montages, it is neither the image of a woman nor that of an amphora that the eye encounters, but a design, a fantasy, where both subjects mingle in an interplay of harmonious curves in well-ordered symmetry. The role of symmetry is less one of formal setting than of poetic justification of the image of an amphora-woman. The final montage which we can see coming to life, in a subtle game of superimpositions and elisions, lays bare the hesitations of the photographer's eye in its effort to perceive the essence of the image.

Shedding the formalistic connotations which a classic critical approach attached to the symmetry on which Maillol constructed *La Nuit*, Blumenfeld gave back to that symmetry its value and its strength as a symbolic structure. His setting leaves the eye no avenue of escape from the awesome frontality which links this work to the oldest representatives of sexuality. Blumenfeld developed numerous variations on the theme of the dual symmetry of the feminine body (breasts and genitals) and face (eyes and mouth). All have the common purpose of imposing on the image a frontality which, at the same time, fascinates and holds off the onlooker. Blumenfeld's autobiographical writings leave no doubt, even in the mind of the lay reader, as to the connection between this theme in his work and his own fantasies. The same could be said of the theme, recurring just as often in his images, of the grid pattern which also conveys the feeling of distance, of interdiction, of taboo. It is doubtful, however, that the problems born of his libido would explain fully the recurrence throughout his work of the two themes of symmetry and grid pattern. One should look elsewhere.

Blumenfeld was fully aware of the contradiction brought about, in the field of photography, by the fallacious assumption of the objectivity of the camera. Photography consists, paradoxically, in establishing, between image and reality, the subjective distance without which there is no art and doing this with an instrument that should, in principle, abolish that distance by the immediacy of a purely mechanical recording. This would seem to be one of the reasons why Blumenfeld felt that in photography, contrary to what happens in painting, one cannot "say" things without, at the same time, explaining why they are said and how the image which expresses them has been constructed. Both symmetry and grid pattern imprint a contradiction on the image. The symmetry expresses the contradiction between life and symbol, the grid becomes the symbol of the ever-present restraint on an impulse, toward a reality forever elusive.

There were many other forms of symmetry on which Blumenfeld played with great subtlety as his image evolved toward its final stage. For him, the finalization of the material process which has, as its end product, the printing on paper, must not be allowed to set the image and give it a clearly defined and final

meaning. By juxtaposing and comparing the images, Blumenfeld sought to call that meaning in question again, keeping open the approaches through which the eye and the mind will probe yet further and extend their perception beyond the physical data. Such, at least, seems to have been his intention when he conceived the idea of grouping a number of his photographs in pairs.

The avant-garde in the cinema had already in the twenties at times made use of the parallel montage of two sequences. But the aim was essentially didactic—either sequence B commented and explained sequence A, or the two sequences were complementary and made out a "one-way" story. Blumenfeld's diptychs, on the contrary, rest on the ambivalence of the two confronting images. Theirs is a dual meaning. Each image makes its own statement in relation to the other. A symmetry is thus established which, as the eye moves from one to the other, creates a third image or, more exactly, a fluid and elusive sequence of images, successive approximations of a theme which will never be expressly formulated. The triggering of the process presupposes some formal analogy, be it consonance or contrast, between the two images. It was with great virtuosity that Blumenfeld played upon the symmetry of the positive and the negative, the single and the multiple, the centripetal and the centrifugal, the enclosed and the open.

Transparency becomes the result of his montages. Juxtaposition becomes, in a way, a superimposition. The sideways movement of the eye gives it depth of vision as it draws the images alternately together and apart. It is transparency that Blumenfeld aimed at when he used a grid pattern. The screen effect can be achieved by varied means—the structure of an object, in close-up, combines with that of another, in the distance, as is the case in a shot of New York taken through a venetian blind. At other times, the screen has no logical relation to the subject and can simply be a fine cloth thrown over the subject's face. The effect can also be achieved by reticulation of the negative so that it is simply in the texture of the print, as is the case in "Portrait Al Fresco."

Blumenfeld understood that, by defocusing space, the analytical grid had not so much enabled the Cubists to bring the object onto the flat surface of the canvas—as was their wish and their belief—as given that object a poetic mobility which was later to be used extensively by the Surrealists. By superimposing on the object a patterned structure, Blumenfeld was not trying to create a romantic blur or push that object into a misty distance where it would lose its reality and its truth. His aim was to free the subject from the restrictions imposed on it by the geometry of the space in which it was set and replace the feeling of physical distance by one of subjective separation, imprecise, unstable and insurmountable, such as could be bought about by desire, recollection, dream or anguish, and in so doing, give the image depth and intensity.

To take photographs of works of art or architecture was, for Blumenfeld, to capture and express, through the image alone, the meaning and statement of that work, its quest, arduous or intuitive, for style. To take fashion photographs could not be simply to describe, in an artfully flattering way, the designs of some more or less inspired couturiers. It was not, either, to take shots of Woman. The aim could only be to show the process of stylization through which fashion takes women and the part played by photography in that process. It was Blumenfeld's

good fortune that his approach was exactly the one required, as he appeared on the New York scene, by the strategy of certain editors of fashion magazines.

War was on, but there would be a postwar and no one doubted that, in the area of mass communications, the postwar era would witness the absolute primacy of the photographic image. Henry Luce, with his successful launching of *Life* in 1936, had expressed his unshakable faith in the all-conquering power of the "picture magic." Whatever that power, however, it had to be harnessed to function for its well-defined objectives. There was no sound economic sense in taking shots of fashion collections simply to give middle-class women readers a chance to dream about them, and then, overcome by old puritanical reflexes, to cast away their dreams. It was essential to attack those very reflexes, free the upper-middle-class woman of her guilt complexes by using the image—and the image alone—to convince her that by taking part in the collective enterprise of stylization, she was participating in the definition of the American way of life; that playing the fashion game was playing the social game from which no one has the right to withdraw; that it was contributing to the integration of the American nation, stating one's belief in the free world and the ultimate triumph of the market economy.

On the focusing screen of his camera Blumenfeld had scrutinized the many stylizations which art had given to the body, movements and face of Woman, from the most primitive idols to the most sophisticated creations, evolving through the centuries a constantly remodelled myth. His intimate knowledge of the subject enabled him to take his place, with no apprehension, in the continuing process. He knew, however, that he must not allow his knowledge to intervene between himself and the problem he had to solve, the problem, radically new and somewhat paradoxical, of the mass diffusion of an elitist "model." He had to erase from the viewer's mind the image of fashion drawing which, in the twenties, had had great prestige.

We shall discover, as we read on, how the ex-Dadaist used his formidable experience, then went beyond it to create, by the extraordinary visual mechanics of his work for *Vogue,* a new type of image and almost a new woman—the cover girl.

Was this a new Blumenfeld? Certainly not. But within the apparent commercial constraint there emerges a Blumenfeld paradoxically free to determine the essence of the object of his desire and that of his photography.

Maurice Besset

HOW TO BECOME A PHOTOGRAPHER

"I wanted to *live,* to infect the world with my spirit."

Erwin Blumenfeld's passionate nature, his ego, come to full expression in this one sentence, which appears at the very beginning of his autobiography,[1] right after the mention of his birth in Berlin on January 26, 1897. All the action of his life—his struggle—is between physical and financial survival and his inordinate ambition to influence the world.

Amateur

In 1944, in an interview in *Photography,*[2] Blumenfeld described himself as an amateur. This description and his aggressively forceful desire to leave his mark on the world only *seem* contradictory, a fever caught when, at the age of ten, he took his first pictures; this turned him into "a true believer, a devoted practitioner, in other word, an amateur." [3] But this "childlike creation" must not mislead us; it does not preclude seriousness, boldness in his work—on the contrary. Henri Matisse stated: "All we see in everyday life becomes more or less distorted by habits acquired over the years and this fact is probably even clearer in a time such as ours, when films, advertising and magazines drown us daily in a flood of preset images that are to the visual field what prejudice is to the intellectual. The necessary effort to free oneself from such images requires a kind of courage and that courage is necessary to the artist, who must see all things as if for the first time: throughout our life we must look as we looked when we were children." [4]

This passionate, positive, receptive attitude never changed in Blumenfeld, whether in his art or in the way he dealt with his everyday problems. Violently, whether through obscenity or uncontrolled laughter, he allowed the "black areas" of his life to burst into the open.

Chaplin

Uncontrolled laughter and humor were his means of escape, his defense against the rich, the strong, the wicked. That is possibly the reason for his admiration for Chaplin and identification with the "little tramp." "Charlot" appears several times in his collages of 1921 and in his autobiography. Blumenfeld's sensual, at times even obscene descriptions in his autobiography, but also the subservient, defamatory picture that he gives of himself, can be explained by the analogy he sees between himself and "Charlot, the symbol of the persecuted Jew." This would fit in with Hannah Arendt's analysis of Chaplin's persona: "The world Chaplin creates is very down-to-earth—grotesquely caricatured perhaps but nonetheless starkly real. It is a world from which neither nature nor art offer an escape, in which humor is the only possible shield against all attacks and temptations." [5]

Wildly Beautiful Dreams or Sleepbabysleep

The other means of escape from reality is sleep, said Blumenfeld, talking about his pillow, which he calls his first mistress: "in 1940, in the most inhuman of French concentration camps in Vernet d'Ariège. . . . The irresistible magic of

'sleepbabysleep, you will forever sleep' is always renewed in the rocking loveplay of waves, up and down, back and forth, until there is no return from the abracadabra of these waves, until one sleeps . . . until I am in the embrace of a dream, that master of sleep. Sleep, never dreamless, has become the better half of my being: . . . My inspiration comes from dreams . . . then I fly freely toward heaven: flight in flying." [6] Sleep and its magic do more than bring forgetfulness. They are also a source of inspiration. Through them the artist encounters dreams, wonderland, illusion. It was thus that the Surrealists explored the forbidden realms of the subconscious, the supernatural, the dream, madness, hallucination, in their effort to unite the individual and the world.[7]

The theme of sleep is one of the indispensable keys to understanding Blumenfeld's work. It is a curious fact that this theme recurs constantly in his autobiography as well as in his photographs; it is a link between those two means of expression. A reclining woman, shrouded from head to toe like a mummy; portrait of a woman with her eyes closed; naked woman lying asleep on a cloth; sleeping woman floating in unlimited space, seen through a transparent veil strewn with flowers. That kind of sleep is linked to death and sex. This image and this condition merged with that of death and that of his relationship with women. Thus the "voyeur-photographer" can "hold on" to his beautiful goddesses in the state of sleep; [8] they cannot escape him, as if they were only accessible in dreams, in that space in which he becomes real, in which he becomes "a libertine: each night brings wildly beautiful dreams that take hold of you. As you awake, the magic maze evaporates into nothingness. The world is full of wonders but there is no greater wonder than the dream. Awake, I have never reached its creative power." [9]

Sustained by humor and sleep, Blumenfeld carried on the struggle of life. "I wanted to *live*, to infect the world with my spirit." The answer lies in his work, and he managed to realize the "inconceivable miracle of the New World": to earn his bread with what he called a "low-grade craft" as well as to become a great photographer.

Image for Posterity
Blumenfeld was determined to leave a particular image of himself to posterity. It consists of his autobiography and a selection of one hundred photographs which he considered his best. It was important to him to leave a perfect, finished work, in which no traces of the creative process could be found. For nearly fifteen years he worked on his autobiography, and he picked his hundred best photographs again and again, without ever being totally satisfied. Only his death in 1969 finished these "posthumous" masterpieces. His worry about his posthumous image can have several reasons. It may be the fear of being misunderstood, or the wish to insure a fair place in the world for himself, or a combination of both. "To be understood was one of the imperatives of my youth, my life, my time." [10] We must note this relationship between self and the world. In the chapter "My Olympus," he vividly expressed the confrontation between his artistic self and that of the other great artists whom he honored and to whom he turned for inspiration.

11

Cultural Universe

That chapter [11] should be quoted in full. It reflects the structure of both his book and his artistic technique: the collage. It also introduces the cultural cosmos to which Blumenfeld—like a Renaissance artist, universal and inquiring—devoted his artistic search.

"My Olympus"

Shakespeare Greek tragedy Marlowe
Molière Wedekind Strindberg
Mozart Monteverdi Purcell Bach Vivaldi Handel Gluck Haydn Jazz
Bosch Breughel Grünewald Cranach Holbein
Greco Rembrandt Vermeer Chardin Goya Daumier
Van Gogh Gauguin Cézanne Degas Toulouse-Lautrec
Seurat Douanier Rousseau Futurists Cubists Dada George Grosz
Early Gothic tapestries unknown masters
Villon Charles d'Orléans Scève Homer Ovid
La Fontaine Baudelaire Rimbaud Verlaine Apollinaire
Gryphius Claudius Heine Wilhelm Busch Morgenstern
Ringelnatz Struwelpeter
Balzac Stendhal Flaubert Maupassant
Grimm's fairytales Poe Gogol Dostoievski Kafka
Casanova Montaigne Diderot Voltaire Swift Sterne
Egon Friedell: Cultural History of Modern Times
Lao-tse Schopenhauer Nietzsche Freud Plato
Sourire de Reims Greek-archaic
(from the Cyclades to the sixth century)
Egypt Maya Negro sculpture pre-Columbian
New York Paestum Cathedral of Laon
Melies Charlie Chaplin Buster Keaton
Marx Brothers Asta Nielsen

Blumenfeld's pantheon encompasses a cultural spectrum without limits of time or space, from the Middle Ages to contemporary times, from Europe to America. Literature may well have the lion's share, but philosophy, landscapes, painting, sculpture are also represented. It even includes film, an art form so close to photography—paradoxically absent from his "My Olympus."

Autobiography

Blumenfeld started writing his autobiography around 1955. He was fifty-eight. This moving incursion into his youth was perhaps an endeavor to control and overcome the anxieties it left in him, now that he had returned to Europe—where, amid horrors, terrors, obscenities, escapes, he witnessed the collapse of the Old World. One can wonder why his view of the present, of the American reality, seems so much more superficial, more stereotyped: the Mafia, homosexuals, the cosmetics industry. Did he lose his wild glance, his aversion (inherited from his grandfather Henry) to "hats, friends, family, society, America?" [12] Were the anarchism and nihilism from his Dada period blunted by advancing age? Are there

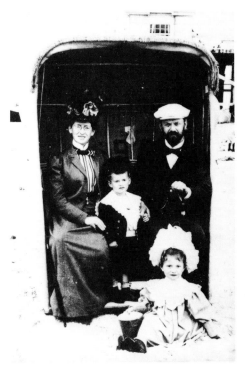

Father, Mother, my sister Annie and I, on the beach at Ahlbeck, 1900

fewer accounts to be settled in the present than in a world in which he was banned, persecuted, ridiculed and imprisoned? But his book is only seemingly cynical: Blumenfeld himself was a victim of life's cynicism; he had to hide his tender feelings and escape into a dream world. Between the nostalgia for his youth and his irony there is a whole complex web of suffering, struggles and love, veiled by the author's extreme discretion about his family and his deeper personal attachments.

Erwin Blumenfeld's rather narcissistic autobiography prompts another observation. Moholy-Nagy, Raoul Hausmann, Gisèle Freund, Lartigue, Man Ray and Brassaï had made photography the central axis of their writings; they dealt with the status and professional life of the photographer, his theoretical and practical researches. Blumenfeld did not place photography in the foreground. He makes few references to it. The aim of his book was rather exorcism: to rid himself of his childhood memories, to settle accounts with his mother and with the orthodox Jewish milieu of his youth in Berlin.[14]

The relationship between the autobiography and the photographs is established by the book's structure, which resembles a photographic montage with very detailed analyses of particular points. And however deep the distortion between his "realistic" style of writing and his "beautiful pictures" appears to be, the appearance is deceptive. The interaction of the written and the visual throws a stronger light on both and helps give a meaning to some of Blumenfeld's omissions and emphases—for instance wife, children, family, death, sleep.

From Blumenfeld's artistic production (photos, collages, paintings), from his autobiography, from the recollections of his family, friends and collaborators (the art director of *Vogue*, models, assistants), from recorded interviews, books on the history of photography [15] and art, reviews, magazines, one can retrace his life and follow the milestones in his work. I have tried to relate his life and his work to his times and, above all, to gauge the new avenues he opened up for us.

I tried in vain to find a negative judgment of Erwin Blumenfeld. All those I interviewed, especially the women (his favorite confidantes and collaborators), unanimously draw the picture of a lively, passionate, complex, difficult, cultivated, amusing, generous man, who was extremely attentive to the emotional needs of those around him but never spoke about his own. And that was probably the reason why I also wanted to get to know him.

1. Erwin Blumenfeld, *Durch tausendjährige Zeit* (Frauenfeld, 1976).
2. *Photography* (October 1944). 3. Ibid.
4. Henri Matisse, *Ecrits et propos sur l'art* (Paris, 1972), p. 321.
5. Hannah Arendt, *Jewish Social Studies* (April 1944), p. 99.
6. Blumenfeld, *Durch tausendjährige Zeit*, p. 63.
7. In his *Histoire du Surréalisme*, (Paris, 1964), Maurice Nadeau goes so far as to give the title "the era of slumbers" to the early period of the movement (from 1923 to 1925).
8. Plastic fantasies that could be compared to those of painter Gustave Courbet, the lover of Woman, whom he often painted in her sleep in a posture of abandon.
9. Blumenfeld, *Durch tausendjährige Zeit*, pp. 63–64. 10. Ibid., p. 137. 11. Ibid., p. 158. 12. Ibid., p. 43.
13. For the generation of photographers from the interwar years, the main outlet was through photographic reviews and the advertising industry (newspapers, advertising folders, books, posters). But only with the advent of art books, whose production was perfected in the 1920s, were photographers able to compete with painters: *Champs délicieux* (1929) by Man Ray, *Métal* (1927) by Germaine Krull, *Antlitz der Zeit* (1929) by Auguste Sanders, and *Paris Seen* by Kertész.
14. It consisted of 412 pages, half of them devoted to the Berlin period (his first twenty-two years) and a mere ten for the period he spent in Holland, which was almost as long (seventeen years).
15. A great part of the history of contemporary photography is to be found within the pages of the illustrated press. The lack of interest on the part of European museums and libraries in collections of magazines such as *Vogue, Harper's Bazaar, Elle, Life, Paris-Match,* etc. becomes painfully obvious when it comes to doing any research work on contemporary photography.

BERLIN

At the beginning of the century, Berlin, capital of Germany, where Blumenfeld spent his childhood, was an unusual and explosive mixture of cultural, political and social ferment; its fragments would soon shower on distant, receptive lands. "Death in disguise was lying in wait at every street corner. Berlin swarmed with provocative dilapidated tarts in lacy black silk stockings (only prostitutes wore them) on high-heeled, tightly laced patent leather booties (born of masochistic dreams), and even more tightly laced corsets." [16] Caught between prostitution and a bourgeoisie smugly admiring the telephone, electric light, phonograph, Gillette blades, radio, film and press photography, the progressive elements of society were trying to invent a "new world."

Broken by the trauma of the First World War, Berlin was floundering in a nightmare of poverty, corruption, and unemployment. In the artistic world Expressionism and Dadaism emerged from this social and political chaos—which was to last until 1933.[17]

Dada

This revolutionary movement, started in 1916 at the Cabaret Voltaire in Zurich by exiles Richard Huelsenbeck, Marcel Janco, Tristan Tzara and Hugo Ball, quickly took hold and, at the end of the war, spread like wildfire to European and even transatlantic cities.

"Dada's complex evolution, its different trends in various centers of development, are a corollary of its antidogmatism. In Zurich, Dada swung between a sort of purity of abstract art and rebellion, between the confusion of existing artistic currents and a desire to create a new one. In Berlin, its character was predominantly populist. It was political and utilitarian, violent and publicity-seeking. In Cologne and Hannover humor covered the spiritual and artistic disquiet, criticism was directed more against the signs of civilization than against the signs of the time. In Paris, Dada was antiphilosophical, nihilistic and scandalous, universal, polemical; but whatever the local coloring, the antiacademic spirit expressed itself everywhere with equal virulence." [18]

Dada Berlin

With the support of journals and propagandists, Richard Huelsenbeck saw to it that this movement of iconoclastic furor found a fertile soil in Berlin. In 1918, in the Hall of the New Secession, Huelsenbeck made his first Dada speech, founded the Club Dada and a newspaper with the same name. Among the collaborators were "Chief Dada" Johannes Baader, "Dada Marshal" or "Dada Propagandist" George Grosz, Huelsenbeck, "Dadasopher" Hausmann, Franz Jung, "Dada Mechanic" John Heartfield, Walter Mehring and Gerhard Preiss. The climax of Club Dada's activities was the International Dada Fair, held at the Galerie Burchard in 1920. The same year, Huelsenbeck published the *Dada Almanac*.

A somewhat distorted manifestation of Expressionism, nihilistic in its denial or destruction of all accepted values, Dada managed nevertheless to engage a number of artists in political action: George Grosz, John Heartfield and his brother, Wieland Herzfelde, and many others joined the Communist party, and

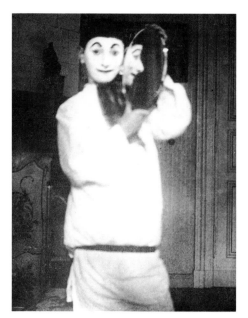

My first self-portrait, as Pierrot, 1911

Self-portrait

fought the social inequities through political agitation and virulent propaganda. But Dada was also a fruitful and innovating movement. It led to typographical experiments, to the constant interpenetration of the literary and visual worlds: George Grosz wrote poems, and his books were illustrated by the well-known Berlin writer Else Lasker-Schüler. The Malik publishing firm, founded in 1914 by the Herzfelde brothers, took its name from the title of one of her novels. Lasker-Schüler was greatly admired by Blumenfeld, who was quite overcome with pride because he had conquered "the black swan of Israel ... the weaver of the Tibetan carpet ... without any outside help, only with my personality." [19]

During a Dada evening in Zurich in 1916, Tzara announced to the assembled audience that he'd like to urinate in various colors. The meeting between Blumenfeld and Grosz took place in similarly dadaistic style, though in more intimate surroundings. "One evening in 1915, much the worse for drink, I went into the men's room of the Café Wellblech in the Potsdamerplatz. A young dandy walked in at the other end, stood by my side, clamped his monocle to his eye, undid the fly of his black-and-white check trousers and, with a single jet, drew my profile on the wall with such mastery that I could not withhold my praise.[20] We became friends. He was the most genial man I have ever known, a great story teller and a forceful draftsman. His name was Grosz. Like Mynona he belonged to Lasker-Schüler's circle. He was her leather stocking." [21]

First Camera

Blumenfeld's childhood in Berlin, at the time of Dada's beginnings, had a fundamental influence on his life. His artistic interests matured and he made his first attempts at painting. He shared his hopes and despairs with his childhood friends. It was at that time, when he was just ten years old, that he acquired his first camera.[22] He got it from his uncle Karl in exchange for ... his appendix—a gesture which marked the transitition from one age to another.

"My life began with the discovery of the magic of chemistry, of the interplays of shade and light, of the double-edged problem of positive and negative." [23] His first photograph was a still life, a theme which he soon abandoned for portraits and women. His first self-portrait, at the age of fourteen, perhaps more indicative of the complexity of his nature, shows him dressed as a clown, his face painted white, his eyebrows arched, his smile and his eyes sad. He faces the camera, holding a mirror which reflects his profile (a technique which he was to use for several subsequent portraits). "We are our own double. Without a mirror I would never have become a man. The depraved call it narcissism. There is no art without a mirror, no music without an echo." [24] At a later date he was to return to this duality within himself and express it in a drawing which showed him half man, half woman.

Gestation—desires—anguishes

It was a period of confused gestations, desires and anguish. "All my childhood has been haunted by the most sinister lusts of fear." [25] It was the period of his first masturbations, of his first loves. "I was born a platonic erotomaniac. I was madly

Der Jungbrünnen (The Fountain of Youth) by Lucas Cranach

Mr. and Mrs. Blumenfeld, 1921

in love with Love, I loved all women, never one woman. . . . I took refuge in the eternally feminine. I gave myself entirely, resolutely, manfully, to what were to become the fetishes of my life—eyes, hair, breasts, mouth.[26] . . . The great museums were to appease my erotic longings. My passion for museums grew accordingly." [27] Berlin had a great wealth of them—the Post Office Museum, the Anthropology Museum, the Decorative Arts Museum, the Imperial Stables, the Hohenzollern Museum, the Museum of Mines and Foundries, the National Gallery. All of Blumenfeld's work reflects his wide culture, his insatiable curiosity. Classical painting has undeniably left its mark on a number of his photographs: "Portrait in the Manner of Greco," of Raphael, homage to Seurat. His Olympus tells us clearly that his interests were boundless. At the National Museum his favorite painting—Lucas Cranach's *Der Jungbrünnen (The Fountain of Youth)* prefigures one of the recurring themes of his own work: the obsession with time. Ugly old women emerge from the fountain's beneficial waters young and beautiful again. "I have never admired young goddesses without seeing those bewitching enchantresses transformed by time into old witches." [28]

Childhood friend

Blumenfeld's childhood friend, Paul Citroen, occupied an important place in his life. The virulence of his criticism in his autobiography only serves to confirm that importance. The Citroen family in Berlin, said Blumenfeld, "made me their entertainer, their court jester, their table companion, and at the same time tried to turn me into a proletarian whom one couldn't possibly introduce to more refined people. They expected me, however, to show them gratitude for having degraded me into the trusted family clown." [30] After obtaining his certificate of secondary education, Paul Citroen could afford the luxury of becoming a painter; Blumenfeld, however, became his family's breadwinner on his father's death in 1913, and went to work for Moses and Schlochauer, where he acquired an intimate knowledge of the world of ladies' wear. He described his friend as "blind to colors as he was empty of ideas. He never brought anything new to the world, but only borrowed, stole. . . . After all the isms had given him the brush-off, he went in for sensationalism and painted, for the Amsterdam art exhibition, an open toilet, with contents." [31]

Was this truth, wounded pride, disappointment, family intrigues or simply bitterness on the part of Blumenfeld? After all, he had to live through both wars and the economic crisis, unable for a very long time to indulge his overriding passion, art. In any case, in 1919 he went to Holland, after his attempt at desertion from the army failed because of his mother's denunciation. In Holland, he again met Paul Citroen, and, more importantly, his fiancée, a cousin of Paul's, who had introduced them in 1915. The courtship had been entirely by correspondence, and the young woman had accepted Blumenfeld—he considered himself the Don Juan of the pen, "the nail biter as man, as hero, as immortal lover" [32]— before they ever met. A year later, in 1916, she came to Berlin to see him, against the wishes of both families. Leentje, "his small, plump Helena with her radiant blue eyes and her dancing blonde curls" [33] became his salvation through the nightmare years of the First World War.

After an uproarious Dadaist orgy,[34] which he describes in his autobiography, Blumenfeld left his native country for that of his bride. "From Germany I only took with me the memory of my Berlin youth. I neither wanted to forget it nor could I." [35]

16. Blumenfeld, *Durch tausendjährige Zeit*, p. 122.
17. On January 30, 1933, President Hindenburg charged Hitler, who had just become chancellor, with the task of forming a new government. It was the beginning of the auto-da-fé of European culture.
18. Tristan Tzara, in the preface to George Hugnet's *L'Aventure Dada* (Paris, 1957).
19. Blumenfeld, *Durch tausendjährige Zeit*, p. 152.
20. Ibid., p. 155.
21. Ibid., p. 156. He was to see Grosz again in New York—"the city of his dreams," where Grosz lost his art.
22. "A camera, nine by twelve, with ultrarapid anastigmat lens, opaque filter, red rubber balls, metallic chassis and tripod. I had been fascinated by photographic equipment for as long as I could remember."
23. Blumenfeld, *Durch tausendjährige Zeit*, p. 102.
24. Ibid., p. 139.
25. Ibid., p. 58.
26. Ibid., pp. 115 and 143.
27. Ibid., pp. 141–42.
28. Ibid., p. 143.
29. Dutch painter, born in Berlin in 1896.
30. Blumenfeld, *Durch tausendjährige Zeit*, p. 107.
31. Ibid., p. 113.
32. Ibid., p. 205.
33. Ibid., p. 206.
34. "Well-built young society ladies, with talent for the movies, are invited to a party at the studio of the painter Grosz, 8 P.M., formal dress! 4 Olivaerplatz." With this sign, nailed to the end of a broom handle, we walked up and down the Kurfürstendamm, like sandwichmen. Eleven men came to our party: Mynona, Grosz, Piscator, Huelsenbeck, Mehring (the seven-month baby who was to become "Pipi-Dada"), Benn, Gumpert, Yomar Förste, Wieland and Muti Herzfelde ("Producer-Dada") and I. Over fifty girls turned up and we had to close the doors because of overcrowding. Ibid., pp. 275–76.
35. Ibid., p. 276.

HOLLAND

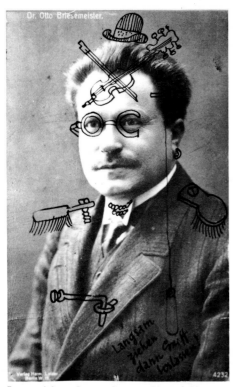

Post card from George Grosz to Bloomfield

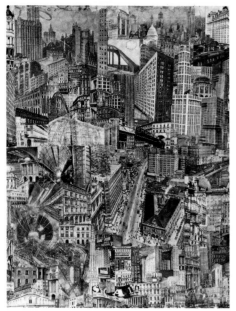

Paul Citroen, *Metropolis*, 1923

Dada and Photography

In 1922, Tristan Tzara enthusiastically welcomed photography: "When all that went under the name of art became stagnant, the photographer switched on his thousand-watt lamp and, little by little, the sensitized paper absorbed the dark outline of a few everyday objects. He had discovered the significance of a sensitive and virgin flash, more important than all the constellations which delight our eyes." [36]

Dada has undoubtedly, because of its collages but also because of photojournalism and commercial advertising, played a key role in the rise of photography in the postwar years.

Director of the Amsterdam Branch of Dada

The works of Paul Citroen and Erwin Blumenfeld fit within the context of the Dada movement. Like John Heartfield, who had changed his name to express his antinationalism, Blumenfeld Americanized his to Jan Bloomfield.[37] For a number of European artists, the United States embodied all their hopes of creating a new world in which man and machine would coexist in harmony.[38] Through letters, articles in various reviews, exhibitions and journeys to Berlin, Citroen and Blumenfeld kept in touch with Berlin Dadaists, the friends of their youth. They were given the title of co-leaders of the Amsterdam branch of Dada by Huelsenbeck. In fact, that branch never really existed; it was a pure fiction concocted by Huelsenbeck and Grosz in their desire to spread the Dada movement throughout the world.

Paul Citroen

Paul Citroen did not take an active part in the Great Dada Fair of 1920. His younger brother Hans, however, exhibited four collages, among them the one titled "Wilson's Eleven Points." In that same year Paul collaborated on the *Dada Almanac*. He himself said that it was Blumenfeld who, in 1919, got him started on the collages in which the city was the subject. From 1922 to 1925 he studied at the Bauhaus in Weimar, where he conceived his *Metropolis* series, exhibited in 1923. This work—a large mosaic made up of rectangles cut out from photographs and postcards of skyscrapers, bridges, elevated trains, stations, etc.—belong as much to Dada (by the selection of material) as to Constructivism (by its structure). Each separate rectangle shows a different spatial perspective—from below, from above, nearby, from a distance, and so on; this creates the impression of motion associated with urban dynamics. Comparisons have often been drawn between this collage and Fritz Lang's film *Metropolis*, produced in 1926.

Bloomfield

Huelsenbeck mentions "Bloomfield" in his *Almanac* as early as 1920. In that year, Blumenfeld had a poem, "Atze Lenzgedicht," in the third number of the review *Der Dada*. He corresponded with Grosz, as illustrated by an amusing

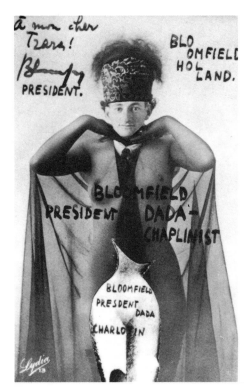

Bloomfield President-Dada-Chaplinist, 1929

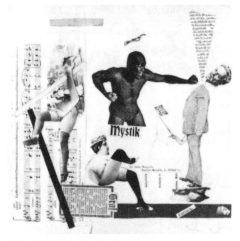

Bloomfield Marquis de Sade, 1921

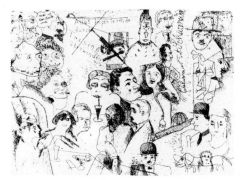

Bloomfield, Citroen, Mehring: Café des Westens in Berlin, 1921

postcard from Grosz to Blumenfeld. This photograph shows a man, formally dressed in suit and tie, adorned with absurd objects ridiculing—in the great Dada tradition—military hierarchy and the the narrow-mindedness and limitations of the bourgeoisie; the whole is grotesquely crowned by a hat. The collage he sent to Tzara in 1920, and which is repeatedly signed "Bloomfield President," consists entirely of cutouts from photographs and texts. This self-portrait, in which the head is the only thing belonging to Blumenfeld, already reveals several of his obsessions: the body of a naked woman seen through a veil; the identification with Chaplin: Bloomfield President—Dada-Chaplinist or Dada-Charlotin. In 1920 Blumenfeld was one of the signatories of the letter which Berlin's Dadaists sent to Chaplin expressing their admiration. Another noteworthy collage, from the year 1921, contains every possible element: music notes; texts—on one of which one reads, among other things, "Marquis de Sade, mysticism, curiosity"; women's legs or other body parts—reminiscent of Bellmer's dolls; a black boxer knocking off the head of a bourgeois wearing an armband with the word "mystic," and from whose mouth a speech balloon comes in the shape of an inverted pyramid, inscribed with Hebrew words. The materials used were silver paper and newspaper cutouts; the whole dynamically constructed composition is underlined by two deep purple bands, which give the collage some color. In 1921 Bloomfield, Citroen and Mehring cosigned the drawing representing the Café des Westen in Berlin, a meeting place for the city's artists and intellectuals (Blumenfeld is on the right side of the drawing).

During his Dutch period, which lasted seventeen years, he lost nothing of his dadaist virulence. On the contrary; not only did he remain true to the Dada spirit, but he also led a Dada life. It is with pride that he tells the story of his arrest on a morals charge on the beach at Zandvoort: one of the straps of his swim suit had slipped from his shoulder! And that was the reason why the "convicted" Blumenfeld never got his Dutch citizenship!

Women, Children, Worries

Throughout this Dutch period he retained his close links with Berlin and with his friends Grosz, Citroen and Mehring. These were years of experimentation. He painted, wrote, gave more and more of his time to photography. They were also years of struggle. Married, with three children, he had a family to feed. He worked in turn as a book seller, a buyer of novelties for a fashion house, an art dealer [39] and the owner of a leather goods shop. The failure of this last venture was to make him turn to photography permanently. During the whole of this period, his mind inquisitive and receptive, he became "a Sunday painter ... my style: futuristic Dada. Three wide-ranging journals (*Variété* in Brussels, *Querschnitt* in Berlin, *Minotaure* in Paris) kept me in touch with the creative world. I thought I was modern but in fact turned out to be classical." [40] After an unsuccessful attempt to get in with the great Berlin photography tycoon Korff—who dismissed his photographic work as a waste of time—Blumenfeld turned his hopes to Paris.

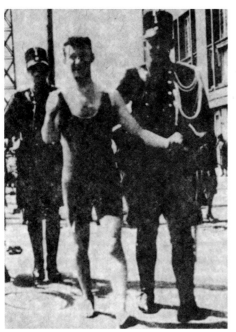

At the beach at Zandvoort

Angel Face

In his moribund shop Blumenfeld developed and printed all night so that every morning a new angel face could shine in "high key" among the remaining crocodile bags in his window. In the spring of 1935, a fair-haired, blue-eyed Parisienne, the daughter of Georges Rouault, honeymooning in Holland, entered the shop and asked for a photo of herself like the one in the window. She became the queen of his Paris debut. The Paris review *Photographie, art et métiers graphiques* published three of his photographs in 1936: two portraits of women, one of them Tara Twain, and the picture of a sleeping woman lying on her back, her head pointed toward the bottom of the page, her body swathed like a mummy. The very accentuated contour of the feet denotes a certain "phallic" aggressiveness. The three photos serve as an introduction to Blumenfeld's major obsessions: women, death, sex.

To Be a Photographer

Events pushed Blumenfeld inexorably toward professional photography while everyone was trying to dissuade him. "Failed window dressers became photographers. One was ashamed of a photographer. The fact that in New York one could make hundreds of dollars with one photo was just American bluff. . . . Besides, there were doubts, not entirely goundless, about my talent." [41] Nevertheless, he kept to his decision: "What I really wanted: to be a photographer, just that, art for art's sake, a brand new world, so successfully discovered by the American Jew Man Ray. Whether I could keep a family afloat on that was an altogether different matter." [42]

36. Quoted by Walter Benjamin in *Kleine Geschichte der Photographie* (Frankfurt, 1955).
37. The same thing happened when he opened a leather goods shop in Kalverstraat, Amsterdam; he called it "The Fox Leather Company."
38. Studied more closely, Chaplin's *Modern Times* lay bare that utopia.
39. Blumenfeld, *Durch tausendjährige Zeit*, p. 279. He had tried to start an art business with Paul Citroen.
40. Ibid., p. 284.
41. Ibid., pp. 284–85.
42. Ibid., p. 290.

PHOTOGRAPHY IN THE INTERWAR PERIOD

Certain factors have played an important part in the development of photography in the interwar period. A considerable technical evolution had taken place in the workings of a camera (Leica, Ermanox). It became more compact; with the introduction of the spool, a sensitivity to light quite astonishing for the period was attained, and exposure time was shortened. Suddenly amateurs, women, laborers, self-taught people, all could take pictures. The camera even became a child's toy. One must not forget that Blumenfeld was given his first camera when he was ten!

Industry—Propaganda—Cities—New Photography

Both industry and political propaganda were prompt to grasp the possibilities of this new medium, which made it possible to quickly reproduce thousands of copies of a given picture through press and posters. Photography, born of scientific and technical progress, soon became, quite naturally, the expression of the "industrial world." The relation of cities and the new photography is expressed by the Russian photographer Alexander Rodchenko in his 1922 article, "The Ways of Contemporary Photography." "Today's urban landscape with its multi-storied buildings, the special designs of its factories and business premises, the show windows that are two or three stories high, the streetcar, the automobile, the illuminated advertising signs, the transatlantic liners, the airplanes, all this has of necessity changed the interpretation of visual perceptions, even if the changes were at times tiny. The camera alone has the technical ability to give a true image of present-day life." [43]

At the Bauhaus

As early as 1928, the new director of the Bauhaus at Dessau introduced photography as an official part of the curriculum. And even earlier, in 1923, Laszlo Mohony-Nagy spoke about his photograms. The following year the Bauhaus published the seminal book on the theory of photography, *Malerei, Photographie, Film.*

Walter Peterhans was in charge of the photographic studio at the Bauhaus. The influence of his still lifes of 1933—compositions of sheer tulle and flowers, objects playfully floating in space—can be found in some stocking ads that Blumenfeld produced in the United States in 1941. They show women's legs, two, three or more, lightly suspended among flowers and multilayered lengths of cloth.

One of the photographers of the period was Otto Umbehr, known as Umbo, who shared Blumenfeld's cultural background. He started in Berlin in 1923 as assistant to film director Walter Ruttmann and in 1926, with the help of Paul Citroen, set out on his own career. He did portraits and nudes, and from 1928 worked with the famous Dephot agency. Blumenfeld had carefully followed his work—multiple-exposure portraits of women and closeups of nudes.

Photojournalism

It was in Germany that photojournalism flowered. Heartfield published his fa-

mous photomontages, warning of the imminent danger of Hitler's rise to power, in the *A.I.Z. (Arbeiter Illustrierte Zeitung)*. The *Berliner Illustrierte* and the *Münchner Illustrierte Zeitung* and their editors in chief Korff and Lorant discovered the most talented photographers of the period and attained, at the time of their greatest success, a circulation of two million. With their low cost (25 pfenning) they could thus reach the masses. Blumenfeld recollects: "My birth coincided with that of photojournalism. Up to then the daily news, too cleverly illustrated, took many weeks to come out in *Die Woche*. Suddenly the *Illustrierte* had nearly instantaneous life-like photoreportage on the Emperor which eclipsed anything seen thus far, including Max and Moritz." [44] Blumenfeld's 1933 photomontage of Hitler's face superimposed on a skull recalls the violence of Heartfield's photomontages. In 1942 this photo was used in an American flyleaf, millions of which were thrown down over Germany. The head being the main identifying part of the body, its replacement by an animal head follows the old satirical tradition which defines men by the animals they resemble. An example of this is Blumenfeld's Paris photomontage (1936) showing the dictator as a calf's head set atop a draped classical bust.

The Urge to Experiment

The great strides made by photography in the interwar years, especially in Germany, France, and Russia (countries which possessed the main photographic studios in Europe), were accompanied by a voracious appetite for experiments and production. Books, journals and photographic exhibitions multiplied. Almost all European art reviews gave photography a greater or lesser amount of space; some, like the Parisian *Photographie,* were exclusively devoted to it. The historic exhibition, "Film and Foto," held in Stuttgart in 1929, was another important step. In the same year, Franz Roh and Jan Tschichold compiled and published a trilingual anthology, *Foto-Auge/Oeil et Photo/Photo-Eye,* of seventy-six photographs from the Stuttgart exhibition. The book became a classic on German photography in the twenties and was followed, in 1930, by its French equivalent, a special number of *Photographie.*

The demand for photography continued to increase, be it for traditional "pictorial" portraiture, industrial advertising, reportage, or political propaganda. The result was a drastic change in the choice of subject, new technical discoveries, an increasing awareness of the economic and ideological importance of photography.

43. Alexander Rodchenko, *Novyi Lef* 11 (1928).
44. Blumenfeld, *Durch tausendjährige Zeit,* p. 162.

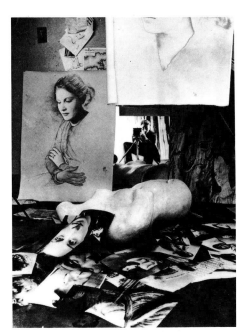

My studio, 9 rue Delambre, Paris, 1936

In spite of the growing interest in photography, Blumenfeld's Parisian beginnings in 1936 were difficult: a new exile, a new language, no studio, no money. Although he made several portraits of clients brought to him by Geneviève Rouault, "the portrait business was not viable," [45] as he wrote in his autobiography, adding that "Paris never pays in hard cash: it builds up one's reputation." [46] He took portraits of Rouault, of Matisse, both of them, according to Blumenfeld, real "prima donnas," grumbling that he made them look old. "Extremely vain; Rouault wrote a poem for me about his 'convict's face.' " [47] Asked to write a few words for the invitation to Blumenfeld's first exhibition, Rouault refused, referring him to Paul Valéry. "He adores being pestered!" Valéry received the neophyte photographer but failed to write a single word! Blumenfeld, with great humor, borrowed a line from Valéry's *Idée fixe* to inscribe on his invitations: "The deepest part of man is his skin." [48]

In spite of his first exhibition at Billier's in March 1936, Blumenfeld, like many other photographers, had to turn to advertising to make ends meet. Later on he was to discover in it great unsuspected possibilities for experimentation: "I was left with advertising, which I held in contempt. Every day, my portfolio crammed with photos, I launched a systematic assault on prospective clients. To my surprise, successfully: I got some orders!" [49] André Guesclin became his first art director for the advertising of hair preparations. His photographs were called "Mon Savon." He also created, for Pathé Marconi, posters of Josephine Baker.

9 rue Delambre

A few months later, in the summer of 1936, Blumenfeld's life took a turn for the better. He found a wonderful studio at 9 rue Delambre. He celebrated the event with a new self-portrait in a mirror in which, squatting behind the camera, he shows us his studio. We can see, lying about the floor or hanging on the wall, several portraits of women and a plaster cast.

The photographer Landshoff found him a model, La Grimm, who, much to his disappointment, proved that beauty and stupidity can sometimes go hand in hand. It was thanks to E. Tériade, wrote Blumenfeld, that "my photos of the sleeping Grimm were published. The series was for both of us the stepping stone of our careers. Even in America! *Esquire* had bought fifty Blumenfeld photos for a new pocket magazine, *Coronet,* and had paid the fantastic fee of fifteen dollars a photo! Tériade of the *Minotaure* had arranged it all. In exchange, I had to give him twenty-two free photos for the first number of his review *Verve.* I had found my niche, I was on the way up." [50]

45. Blumenfeld, *Durch tausendjährige Zeit,* p. 296.
46. Ibid., p. 293.
47. Ibid., p. 295.
48. Ibid., p. 294.
49. Ibid., p. 296.
50. Ibid., p. 302.

PARIS 1933

If 1933 marks the end of cultural life in Germany, in Paris the artistic surge was near its apex. There one could find artists brought by curiosity or exile, among them photographers Kertész, Brassaï, Landau, Capa, Halsmann, Laure Albin-Guillot, and others. The French journal *Vu,* founded in 1928 by Lucien Vogel, was rapidly supplanting the German magazines. Vogel employed the best photographers of the period: Germaine Krull, André Kertész, Albin-Guillot, Munkasci and Capa. Capa's most famous photograph—a Spanish Republican soldier ripped apart by a bullet—was published by *Vu* for the first time in 1936. The review continued to appear until 1938. Henry Luce, who had founded *Life* magazine in 1936, declared that "without *Vu, Life* would never have seen the light of day."

Minotaure

Minotaure was also launched in 1933. It covered plastic arts, poetry, music, architecture, ethnography and mythology, theater, psychoanalytical studies and observations. Tériade was its art director and Albert Skira its administrative director. Blumenfeld, a reader of the review, was particularly interested, among other things, in its investigations of African and the non-European arts. He was very receptive to the direct and expressive character of these arts and he photographed various examples of them—both at the Musée de l'Homme in Paris and in the course of his travels. The striking thing about *Minotaure* was the space it gave to photography: it would often print full-page pictures, as it did in December 1933 with Salvador Dali's photographic composition, "The Phenomenon of Ecstasy," and with photos by Man Ray, Brassaï, Ubac, Manuel Alvarez Bravo, Bill Brandt, Fischer and Eli Lotar.

We shall find the work of these same photographers in *Verve,* created by Tériade in December 1937 (a year after he left *Minotaure),* and which ran until May 1939.

Verve

Verve, a quarterly artistic and literary journal under the editorship of Tériade, stood out because of its extraordinary quality. From the very first number, photography occupied an important place. Man Ray, Dora Maar, Cartier Bresson, Gil, Gos, Eli Lotar, Makowska, Florence Henri, Brassaï, Zucca and Blumenfeld were represented with a total of seventeen photographs. The succeeding issues gave space to the work of Maywald, Bill Brandt, Herbert List, Peterhans, Ecole Fuld, Jeno Denkstein, Rogi-André, Schneider-Lengyel, Pierre Vreger, Thérèse le Prat, Rosie Ney, Hoyningen-Huene, Ewing Galloway, Nus Barma, Claude Simon, Ilse Salbog, Brady, Franz Hanfstaengl, Breitenbach, Octavius Hill. Thus Tériade opened wide the pages of his review to photography, Unfortunately, after 1939 the policy changed and each number was entirely devoted to one single theme—like, for instance, Fouquet's miniatures—to the exclusion of photography. After the war and until its demise with its twenty-fourth number in 1950, *Verve* was devoted to painters only: Picasso, Matisse, and so on.

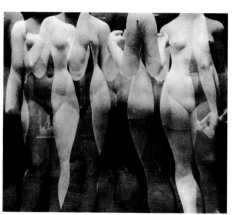

Sculpture by Maillol, *Three Graces*, Paris, 1937

1, 2, 3, 4, 5 . . . 17

In the first number of *Verve*, Blumenfeld presented the following subjects: two close-ups of a luxuriant head of hair, accompanied by a quotation from Georges Bataille; a diagonally angled shot of the tapestry "Bal des Sauvages" at Saumur; medieval sculptures; female nudes; sculptures by Maillol, among them one of the "Three Graces" ("Trois Graces"), which, through multiple exposure and lighting effects, he photographed so that the women can be seen from all angles simultaneously.

From St. Erwin to the Experiments of the Thirties

The yearly review *Photographie* [51] publishes Blumenfeld's shots of architectural works, especially Gothic cathedrals. The theme had a double attraction for him: his namesake, St. Erwin (Erwin von Steinbach), was the architect of the Strasbourg Cathedral, and in addition, the structure of Gothic buildings fit in with his aesthetic experiments with the elements of repetition and sequence.

His portraits, his nudes, his shots of architectural works, of sculpture or tapestry, are in line with the aesthetic preoccupations of the thirties. His major interest was the focus of the picture—always unusual and often in close-up; development of the notion of simultaneity by the multiplication of shapes or by double exposure of a portrait seen both in full face and in profile; development of the notion of sequence through accumulation of a given element; work on the interaction of materials and light and on the use of divided space, blurred, with different levels of sharpness. Those were also years of very successful technical researches into the effects of solarization,[52] multiple lighting, double exposure, and distortion. Ever since he started photography, Blumenfeld divided his working time into a lengthy period of preparing the scene (lights, poses, accessories) and long hours in the laboratory, where he treated his negatives as if they were raw materials. The laboratory was a secret place where, changed into a magician, he gave shape to his fantasies.

Erotomaniac

The female body became the plaything of Blumenfeld's fantasies; he cut it up, elongated it, distorted it, underlining the abstract beauty of an isolated detail. He was obsessed with Woman, transforming her, at times, into an ageless inaccessible goddess, at other times into a sleeping beauty surprised by the voyeur while awaiting the prince charming who will wake her from her long sleep.

The "platonic erotomaniac" placed Woman beyond his reach. From the depth of his childhood memories he remembered his first love paroxysms when he discovered women painted by Cranach, "their insolent beauty all the more naked for their transparent veils." [53] At the age of nine "I had secret dreams of naked women and artists' studios. My governess took me to see my first studio . . . a naked woman slipped behind a screen . . . I had seen her rumpled underwear lying around on the sofa. . . . Over it she put on an even filmier little summer dress of flowered chiffon, especially transparent against the light. There was born in me the desire to see through transparency." [54]

Be it from a distance or in close-up, the "screen" shielding Woman must be pierced. The photographer had to travel a road full of obstacles. The "screen" formed by the surface of the photo could in fact splinter into "big dots" (similar to the silk screen of a newspaper, as later used by Lichtenstein). The picture must then be reconstructed from these dots. Or the body was placed behind a lattice made by the interplay of light and shadow or behind blinds which cut it into "bands." Not only did this screening inflect the mind toward an erotic reading of the picture, but it also introduced added interest to the spatial perception.

Traveler Through Time

Parallel to Blumenfeld's desire to unveil the mystery of Woman one must note his preoccupation with death and with the transcience of time. His women were either like rigid "classical" statues or they were blurred, almost merged into walls on which time had left its marks. His obsession with the flight of time was even more forceful and explicit when he took shots of former models in their old age: Carmen, who had posed for Rodin's *The Kiss,* at the age of seventy; the model for Renoir's Gabrielle, posing in front of the painting; or Yvette Guilbert, who had been painted by Toulouse-Lautrec. He was also making a comment when he set the elderly Laurette Taylor next to a Mexican wood sculpture gnawed by time.

51. *Photographie* published three of his photos in 1936, one each in 1937 and 1938, and two in 1939.
52. Solarization is obtained by exposing the negative to the light before the development is completed. Light acts differently on individual places, depending on the lighting used. This is a very difficult technique.
53. Blumenfeld, *Durch tausendjährige Zeit*, p. 143.
54. Ibid., p. 116.

Blumenfeld's entry into the world of fashion, which assured him of both fame and financial security, was an important step in his life. After bumping his nose "against the hermetically closed doors of the fashion magazines,"[55] he was able, in 1938, with the help of Cecil Beaton, to enter the portals of *Vogue.* One morning it happened: "A siren voice was whispering my praises in English. It was Cecil Beaton. The Lord Byron of the camera, prince in the land of the genii and court photographer, spoiled enfant terrible of *Vogue,* was pouring honey on my bruised soul: my portraits of the daughters of the Vicomtesse Marie-Laure de Noailles were *divine!*"[56]

The rise of fashion photography dates from the interwar period. "Until 1920 one could only find stereotyped stiff drawings in fashion journals. At best, one would occasionally see snapshots of smiling models taken at the races by some horse photographer. Suddenly Baron de Meyer, a Viennese Jew and designer, started taking studio photographs of fashion models. It was a new art form. The American press and the homosexual international brotherhood at once latched onto this new gold mine. I quickly recognized the artistic possibilities and, more slowly, the drawbacks of this exclusive new venture."[57]

Dream Settings or Vanity Fair

From then on the fashion drawings of Bérard, Cassandre and others could no longer compete with those new magicians of light who succeeded in suggesting dream settings, strange and mysterious, against which sophisticated models, dressed in gorgeous outfits, struck exaggerated poses. When he became well acquainted with the world of couturiers, fashion editors, art directors, photographers, Blumenfeld began to "despise this vanity fair which shuns art and where conceited advertising blackmailers pose as arbiters of elegance. Illusions are there to be lost. . . . I remained an outsider. . . . Michel de Brunhoff, chief editor of *Vogue* Paris, enlightened me: 'If only you had been born a baron and had become a pederast, you would be the greatest photographer in the world.'"[58]

Individualist

Blumenfeld did not like collective work and at the time of his only experience as a movie still photographer on the set of Feyder's *Pension Mimosas* in 1935 he noted his lack of aptitude for collective artistic production. This involved him in a number of difficulties with some art directors, "failed photographers who try haphazardly to punish others for their own lack of talent."[59]

On the other hand, his working relationship with individuals was from all accounts a warm one, as he loved to play "father confessor." This physically not very attractive man exuded immense charm. It is with nostalgia that his models remember the time when, during the long hours of posing, he transformed them into goddesses. This is all the more comprehensible when one realizes that the present-day relationship between photographers and models borders on violence—as certain sequences of Antonioni's *Blow-Up* show.

55. Blumenfeld, *Durch tausendjährige Zeit*, p. 296. 56. Ibid., p. 305. 57. Ibid., p. 289.
58. Ibid., p. 306. 59. Ibid., p. 296.

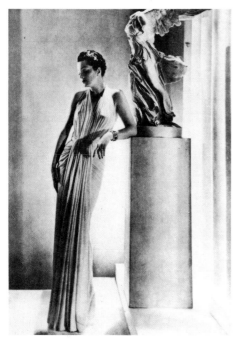

Dress by Alix, photographed by Man Ray for *Harper's Bazaar*, 1937

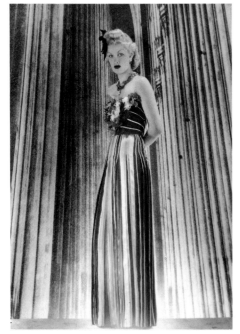

Dress by Chanel, photographed by Blumenfeld for *Vogue*, 1939

If, in prewar years, Paris held the monopoly on haute couture, it was not only for economic reasons but also because of the artistic ferment, the desire to experiment which so characterized the twenties and the thirties. Never was the interdependence between art and fashion so great. Dufy and Sonia Delaunay created new materials, Madeleine Vionnet perfected her cubist bias cut.

Paris naturally became the international center of haute couture: it was there that the Irish Molyneux, the Italian Schiaparelli, the American Mainbocher, the Swiss Piguet, the Spaniard Balenciaga set up their salons. There already were a number of designers in Paris: Madeleine Vionnet, Gabrielle Chanel, Paquin, Alix—whose training as a sculptor was apparent in the folds of her full-length evening gowns, so aptly photographed in front of a Greek sculpture by Man Ray [60] for *Harper's Bazaar* in 1937. We shall find this same classical beauty in the works of Blumenfeld, as shown in his 1939 photograph for *Vogue* of a Chanel evening gown in which the pattern of vertical stripes on the dress melts into the pattern of the stone work of a Gothic cathedral.

Dual Trend

Those two studio photographs by Man Ray and Blumenfeld are in marked contrast to the other trend in fashion photography, which favored the more casual approach of taking the models out of the studio and into the street, the beach, even the zoo! In the film *Funny Face* Stanley Donen (on Richard Avedon's advice) parodied the trend. Its main exponents were Schall, Durst, Parkinson, Landshoff and especially Martin Munkasci. The Hungarian-born Munkasci started as a sports photographer and by the thirties had already become one of the pioneers of photojournalism in Germany. After Hitler's rise to power he sought refuge in the United States. His work brought a breath of fresh air to the new generation of American fashion photographers: Louise Dahl Wolfe, Toni Frissel and especially Avedon. Carmel Snow's recollection of Munkasci's work is of a permanent open-air festival.

Blumenfeld hesitated between the two trends. His first fashion photographs in Paris have a constructivist and dynamic character. In one of them model Liza Fonza-Grieves (the future Mrs. Penn) captured all Paris in a Lucien Lelong gown, precariously hanging onto the Eiffel Tower or walking down its metal stairs. In New York he abandoned this type of photography for a more theatrical style, where every detail of lighting, accessories and posture is carefully studied. The pioneers of that style were Edward Steichen and Cecil Beaton, to be followed by, among others, George Hoyningen-Huene, Irving Penn, and Horst P. Horst (former collaborator of Le Corbusier), whose style was structured, sophisticated, sometimes surrealistic.

Filters

Many factors act as filters throughout the process of photographic production: the art director's choice of clothes, accessories or models, consultation about layout, color, and so on. Great photographers, however, manage to retain overall control.

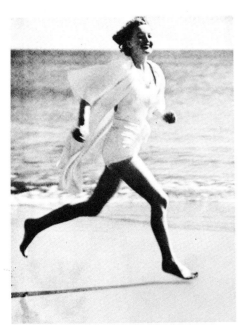

Beach dress, photographed by Martin Munkasci for *Harper's Bazaar*, 1934

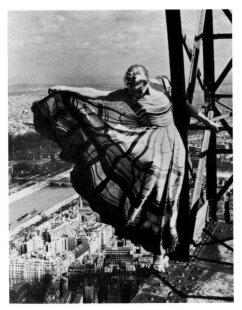

Dress by Lucien Lelong, photographed by Blumenfeld for *Vogue* portfolio, 1939

The Same Uninhibited Beauty of a Dream

Blumenfeld's Parisian production, from 1936 to 1939, is small but nonetheless extremely important. Photographs of architectural works, landscapes and interiors are outnumbered by portraits. These, however, play the same role as do his self-portraits, that is, those photographs in which he could grasp the instant and the "proof" (Amsterdam, Paris, New York, his family, his windows, his travels).

Blumenfeld was primarily a studio photographer, a stage director. His decision to become a fashion photographer is proof of that. Paris marked his entry into the world of fashion as well as the beginning of his aesthetic search—he did not anticipate that it would also allow him to concretize his obsessions. Thus he could express a whole area of his subconscious and thereby approach the practice of the Surrealists, of whose research and experimentation he was well aware. He was particularly interested in Man Ray. The work of both men often appeared in the same publications, spread over two pages, and treating the same subject—Woman. There is such a similarity in their composition and technique (solarization, lighting) that Man Ray's work could easily be mistaken for Blumenfeld's. And that is not surprising because the eyes with which both men looked at women saw the same amazing uninhibited beauty of a dream.

France

"We are all travelers in time, whether or not we know it. Art links us to our subconscious knowledge. It expresses what is really taking place in the nervous system of man." [61]

The end of his stay in France was sheer hell; four concentration camps: Montbard, Loriol, Vernet d'Ariège and Catus. He was German, Jewish and an exile. His thoughts more than once turned toward the razor blade, the ultimate recourse, that he kept in his pocket. Women were his salvation. First of all he unloaded part of his responsibilities onto his wife, whom he urged to "be a man!" He obtained a visa for the United States thanks to the intervention of "Sissy" from Vienna, whom he surprised in the office of American diplomat Oliver Hiss, a keen amateur photographer. Recognizing Blumenfeld, she "jumped to her feet and kissed me! 'Of course Erwin will get his visa. We were talking about you not half an hour ago. Oliver is a great admirer of your nude under wet silk.' " And finally there was Jo: "She looked after two cases of my negatives, and I got them back in perfect condition after the war. No woman has ever done more for my ego. Thank you, Jo!" We too can add our thanks, because without model Jo Regaldi we would not have those prewar photos, in my opinion among Blumenfeld's most interesting work. His writings, his color photos and his collection of pornographic pictures from the year 1900, were, however, lost.

A Wish and a Foretaste of America

"I want to be a color photographer in the United States! He says: Agreed! When a man is capable of stating his wishes so clearly, nothing can stand in his way. He will succeed. You'll be a color photographer in the United States." [62] Thus spoke Tériade, who had just turned down one of Blumenfeld's photos for *Minotaure.*

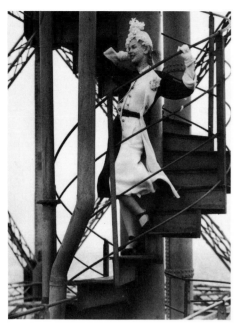

Model Liza Fonza-Grieves on the stairs of the Eiffel Tower, 1939

Blumenfeld had had a foretaste of his new country when he attended "The World of Tomorrow," the world's fair of 1939, in New York. It was on this occasion that he wanted to see Henry Luce, to whom Lucien Vogel had given him a letter of introduction. He eventually dealt with Wilson Ricks who, looking at Claus Suter's dying Christ, exclaimed: "What an ad for Pepsodent!"

The 1939 exhibition in New York announced that, after the war, new young American talent would create an American fashion aimed at two as yet unexploited markets: teenage fashion and sportswear. It also marked the beginning of action painting.

Always Again Paris

In spite of some biting comments by Colette,[63] fashion survived the war years with the help of accessories that may have been ridiculous but at least offered a chance to dream.

After 1945 Paris still held on to its monopoly. Two years later, generously backed by the Boussac textile firm, Christian Dior launched his fantastically successful New Look collection. The name itself shows at which side of the Atlantic the bait was aimed. Fashion in the United States had the added advantage of powerful means of diffusion, such as the fashion magazines *Vogue* and *Harper's Bazaar,* themselves appendages of the cosmetics industry. Make-up makes fashion! American magazines are entirely dependent on advertising. As Gisèle Freund wrote: "The predominant role of advertising is closely linked to the transformation of America from an agricultural to an industrial nation. With the spawning of new industries and new profitable commercial methods, consumer goods became standarized and mass-produced. The development of road and rail networks brought production closer to its market. However, America is a vast country and each region has its own newspapers, specializing in local news. But magazines, either weekly or monthly, have a nationwide distribution and thus reach the entire population. It was therefore of particular importance to advertisers to have their ads appear in those magazines. Between 1939 and 1952 the number of advertisers went from 936 to 2,538 and the number of products sold through advertising rose from 1,659 to 4,472." [64]

Vogue and Harper's Bazaar

The beginnings of *Vogue* date from 1892. It was bought, moribund, by Condé Nast in 1909. Unable to distribute it abroad Condé Nast founded an English *Vogue* in 1916, a French *Vogue* in 1920. The following year his firm also acquired *Le Jardin des Modes* as well as *La Gazette du Bon Ton,* which had been founded by Lucien Vogel in 1912. In 1913, the Hearst newspaper publishing chain bought *Harper's Bazaar.* From then on, the two giants competed fiercely, at times even stealing photographers from each other. The latter were not innocent parties in the game. It was in a very theatrical manner, for instance, that Hoyningen-Huene left *Vogue* to join *Harper's Bazaar* in 1936. When the time came for the renewal of his contract, he read the following clause: "Hoyningen-Huene must desist from calling attention to himself." Enraged, he overturned a table with wine and

spaghetti onto Dr. Agha, *Vogue*'s art director, then hurried off to telephone Carmel Snow, of *Harper's Bazaar,* offering her his services. In a less dramatic way Blumenfeld, after working for *Vogue* for a few years, succeeded, in obtaining a contract from *Harper's Bazaar.* From 1949 on he again worked for *Vogue,* but as a freelance. His art director, Alexander Libermann, was the discoverer of many talents in the field of photography. Himself a man of great culture, a sculptor, painter and photographer, he had studied architecture in Paris with Auguste Perret, painting with André Lhote and graphics with Cassandre. Like Blumenfeld, he arrived in New York in 1941 and found work at *Vogue.* In 1943 he became art director and later held that position for the entire network of Condé Nast publications, both in the United States and Europe.[65]

60. Man Ray's work as fashion photographer at *Harper's Bazaar* is often overlooked. It was thanks to it, though, that he was able to make a living and also to propagandize his avant-garde art—as when he posed a model in front of his painting *Observatory Time—The Lovers,* in 1936.
61. W. S. Burroughs.
62. In an interview in 1951. The development of color photography dates back to World War II. Ectachrome film, which appeared on the market in 1950, enabled photographers to do their own developing. Blumenfeld made enthusiastic use of this possibility. Brassaï stated in 1957: "I had always been opposed to color in photography, but I am discovering America and color at the same time." Quoted in Peter Pollack, *The Picture History of Photography* (1969).
63. "It is a matter of greatest insolence that the fashion for spring 1942 dictates that you, my ladies, whether young or not so young, be guilty of the greatest aberration of taste ever registered in the history of fashion: ridiculous hats in difficult times, fresh flowers crowning worried brows. Net, flower petal, bird, fruit, feather, are offensive as they underline by their newness the honest limpness of a tailored suit, the modesty of a remodeled dress. Don't you, in the end, get fed up with that insolent rose, that mauve bird's nest, those loud ribbons resting on the nape of your neck, those pancakes stuck over one eye, that coiffure fit only for barrel-organ monkeys, those inkpots, those tartan lids, those wheels with multicolored spokes, those humbugs, those fragile arrangements which you take into the subway and sometimes—for there is justice—have to leave there?" (In *Du,* July 1942, extracted from the *Tribune de Genève.)*
64. Gisèle Freund, *Photographie et société* (Paris, 1947), p. 132.
65. They include: *Mademoiselle, Glamour, House and Garden, Brides, Maison et Jardin, L'Uomo, Casa.*

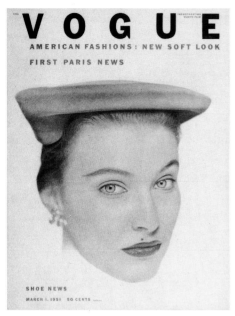

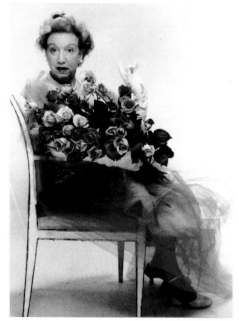

Recollection of François Clouet, photographed by Blumenfeld for *Vogue* cover, 1951

Elizabeth Arden

Blumenfeld's arrival in the United States in 1941 marks the beginning of a meteoric rise which made him the best-paid freelance photographer, commanding a fee of $2,500 per photo. At first he accepted help from another famous exile, whom he fails to mention in his autobiography: Martin Munkasci. It was Munkasci's studio that he used before setting up his own superb studio overlooking Central Park, Blumenfeld Studio, Inc., 222 Central Park South, in midtown Manhattan.

Devastating Whirlwind.

From the very first day he found himself in the midst of the competitive, devastating whirlwind of fashion photography. Carmel Snow, editor in chief of *Harper's Bazaar,* got him started: "Huene gave us two impossible pages and he is now on vacation . . . and you can regale me with your war adventures thereafter." [66] So he replaced Huene, and the following day received a note from Carmel Snow. Blumenfeld exclaimed: "Love on the first night for eight hundred dollars: America for you."

"New York, this hyper-alive metropolis, an eighth wonder (after the Pyramids, the Acropolis, the Roman forum, cathedrals), is a symbol of power and not a work of art. It is a quantity without quality, money without spirit—a giant trinket. Good taste has fallen victim to mercenary critics, the theater has degenerated into show-biz. It is a collosal bluff!" [67]

Bluff and Contradiction

He created of New York, of the United States, an intense, outrageous, caricature-like picture: "Gadgets: mountains of junk, intrigues everywhere, beauties improbably daubed with paint, powder, makeup, nylon underwear, nylon eyelashes, artificial light, phony shadows, real falsies, false baby teeth, artificial tears, artificial smiles, dyed hair, plastic nails, rustling slips, waistcinches by the inches, a hopelessly tangled excess, everything is always too much for everyone." [68] He played the game, nonetheless.

Wasn't he one of those European exiles who injected new life into America's pictorial creativity in the postwar years? Didn't the pop art of the sixties find its inspiration in those goddesses entirely created by the mass media, to the point of making the lipstick a sculpture? Blumenfeld was caught in a contradiction: he was a harsh critic of this society, yet at the same time served it with a considerable photographic production. Why? Was he making up for his years of poverty, of exile, of concentration camps, of struggle for survival?

Photographers of Today

He continues to refer to the classical painters (homage to Seurat, to François Clouet—for a *Vogue* cover—medieval-style illuminated borders for the photo as taken from the Cloisters), and he states, quite rightly: "The influence of photographers on the world of today is far greater than the old masters would ever have dreamed of. There is one thing we have in common with them: we too have

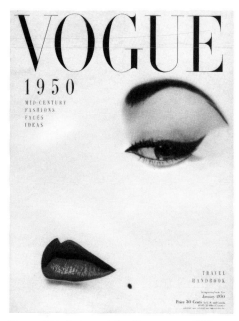

Blumenfeld photograph for *Vogue* cover, 1950

Blumenfeld photograph for cover of *Votre Beauté*, 1937

a patron, the great magazine—with all the advantages and disadvantages that this entails. Each page is seen by millions of people and on our shoulders rests the responsibility for tomorrow's taste." [69]

Blumenfeld did thousands of photographs and hundreds of covers for the greatest American magazines—*Harper's Bazaar, Look, Cosmopolitan, Photography, Life, Vogue*—also for European ones—*Picture Post* in London, *Graphis* in Switzerland, and many others.[70]

His advertising photographs were spectacular. Of Elizabeth Arden and Helena Rubenstein he wrote: "Those two hideous harpies, who only held on to life with the help of Swiss monkey glands mixed with cocaine, trying to recapture their youth, running around dressed in girl's clothes, could not remember the name of friends they did not have, but never forgot the formulas of the thousand and one products that earned them millions." [71]

He portrayed them looking years younger than their age—those are the only photographs which he took a malicious delight in retouching.

Portrait Masks

Several covers of *Vogue* are portraits of women. At times they look like painted masks on which the flow of lipstick becomes the indispensable element. It is worth noting that Blumenfeld made up his models himself with stage makeup (as a child he had wanted to be an actor), and even maintained that he suggested color combinations to those "American divinities." The portrait on the cover of *Vogue* 1950 is interesting in that connection. It can be compared with the February 1937 cover for the magazine *Votre Beauté*, in which two eyes, a mouth and four color lines are set on an entirely white background. The *Vogue* page is also all white, on which tinted eyes, mouth and mole appear, the color having been added at the time of printing. In relation to the recurring theme of the inaccessible woman, this cover once again represents a screen, in this case the makeup, which acts as a mirror of a man's desire. The fact that a face is used for the cover is, according to Libermann, due to two factors: first, the formidable pressure exerted on magazines by the cosmetics industry; second, the conclusion arrived at by the psychologists and sociologists hired by those magazines, that a face on the cover attracted more buyers than a full-length portrait, which made reader identification difficult.

Cadillac and Fashion Show

Another advertising photograph, this time for Cadillac of Detroit: car and woman blend in a seductive interplay of legs and caresses while the photographer-director cuts off a whole wing of the car for the sake of a deep-angled shot.

Blumenfeld also directed a fashion show organized by the Dayton chain in Minneapolis for charity. He had at his disposal clothes supplied by the best designers, as well as the five most beautiful models—Renée Breton, Tess Mall, Dolores Hawkins, Anne St. Marie and Bani Yelverston. Under his masterful touch the magnificent clothes came to life, like butterflies, for the one day of the show!

Cadillac. Nancy Berg. For *Vogue*, 1956

Jackie Gleason, photographed by Blumenfeld for the cover of *Cosmopolitan*, around 1953

Self-portrait

Celebrities

Blumenfeld became a much sought-after portraitist. Musicians, painters, fashion designers, actors, dancers, singers, writers joined the list of his sitters, among them Marlene Dietrich, Grace Kelly, Ginger Rogers, Paulette Goddard, Audrey Hepburn,[72] Eugene O'Neill, Jacques Lipchitz, Cole Porter, Lucien Lelong, Jimmy Durante. Worthy of note too is the portrait of Jackie Gleason, in which the famous American television comic's five faces are wittily caricatured by Blumenfeld. His face framed by two pairs of legs belonging to dancers from his troupe, the lacy pattern of his tie matching the pattern of the dancers' tights, the Gleason caricature fully captures the essence of the American joke. Photographers play a great part in turning American stars in legends. Milton H. Greene, Marilyn Monroe's "official" photographer, was a great admirer of Blumenfeld's work.

Taking Stock

The end of Blumenfeld's collaboration with *Vogue*, in 1955, was attributed to a difference of opinion between the art director and himself, but this was probably just an excuse. Blumenfeld apparently felt the need to take stock. At the top of his profession, he lived in one of the most luxurious apartments in New York, owned a studio and a vacation home. He could go to auctions and acquire old books, works by early American painters, beautiful furniture; he could travel to New Mexico, Las Vegas, New Orleans. And he came to the realization, like Goethe before him, that "what one craves in one's youth comes in surfeit in old age."[73]

"Un-American" to the end, he remained emotionally very attached to Europe. It is therefore not surprising that his selection of photographs should lean heavily toward the work created in Europe or at least rooted in his European experience.

Hendel Teicher

66. Blumenfeld, *Durch tausendjährige Zeit*, p. 393.
67. Ibid., p. 414.
68. Ibid., p. 395.
69. From an interview quoted in A. Libermann, *The Art and Technique of Color Photography* (New York, 1951).
70. *Life*, in 1941, published his photos under the title "Let Us Talk Pictures with Blumenfeld." *Picture Post*, a journal founded by immigrant Stephan Lorant, published double spreads of photographs by Blumenfeld. *Graphis*, in its way very classical, printed some of the pictures belonging to the "hundred best."
71. Blumenfeld, *Durch tausendjährige Zeit*, p. 418.
72. Audrey Hepburn has the part of the model for fashion photographer Fred Astaire in Hollywood's musical comedy, *Funny Face*, by Stanley Donen (1956), for which Richard Avedon, himself a fashion photographer, acted as consultant.
73. Blumenfeld, *Durch tausendjährige Zeit*, p. 395. The heading of the chapter about his life in the United States.

MY ONE HUNDRED BEST PHOTOS

WE NOW YIELD the stage to Blumenfeld's photographs. He worked all his life on the selection of the hundred pictures that illustrate this book. He intended to have them appear in a volume to be called *My Hundred Best Photographs*. Fashion photographs (only a few), photographs of travels, sculptures, architecture, portraits, and nudes are included.

A selection of black and white photographs, a round number, divisible by two. He suggests to us a study based on comparison, similarities and contrasts of these pairs, a study that can also be said to plunge us to the heart of his obsession with Woman. He "catches" her with his camera, "dis-enchants" her by reducing her to single elements (breast, eye), or loads the picture down with all the destructive weight of time. With the help of mirrors and transparent veils he elevates beauty to fetish. "How seriously I take beauty! All my portraits reflect my vision. The artist lives from variations on a single theme."

These photographs, with their rich choice of subject, are the results of technical experiments and, for the period, great innovations. In his studio, proscribing glue, scissors and touch-up brush, he amused himself, like a child, by perfecting solarization, superimposing two negatives and developing them simultaneously, putting wet negatives in the refrigerator to get frosty effects. He played with carefully studied lighting, totally new angles, motifs seen through fluted glass or reflected in a mirror. His stage setting and his laboratory work were closely linked: for him a photographer's work started with determining the visual angle and ended with the glazing of the print. "Day and night I try, in my studio with its six two-thousand-watt suns, balancing between the extremes of the impossible, to shake loose the unreal from the real, to give visions body, to penetrate into unknown transparencies."

THE PHOTOGRAPHS

Erwin Blumenfeld did not date or sign any of his photographs. His early photographs were all 9″ × 12,″ on which he commented, "the size 9″ × 12″ has become so much a part of me that it is like a lover. Thirty years later in the United States, when I was forced to think in terms of 4″ × 5″, it was more oppressive than the New York summer heat."

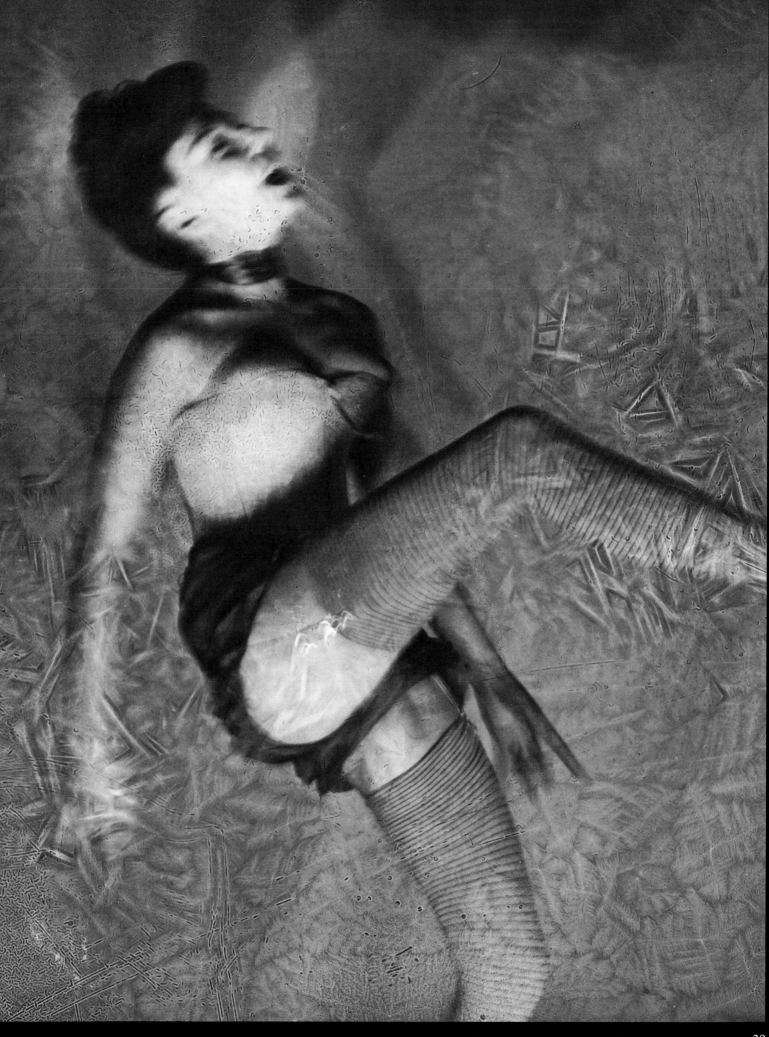

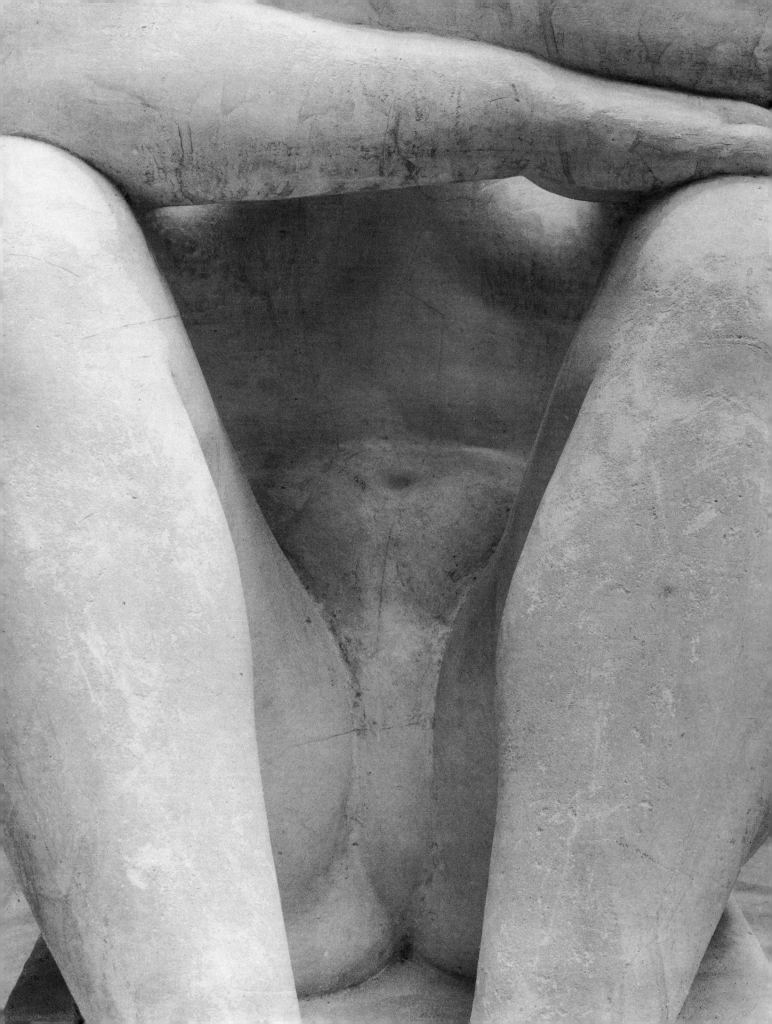

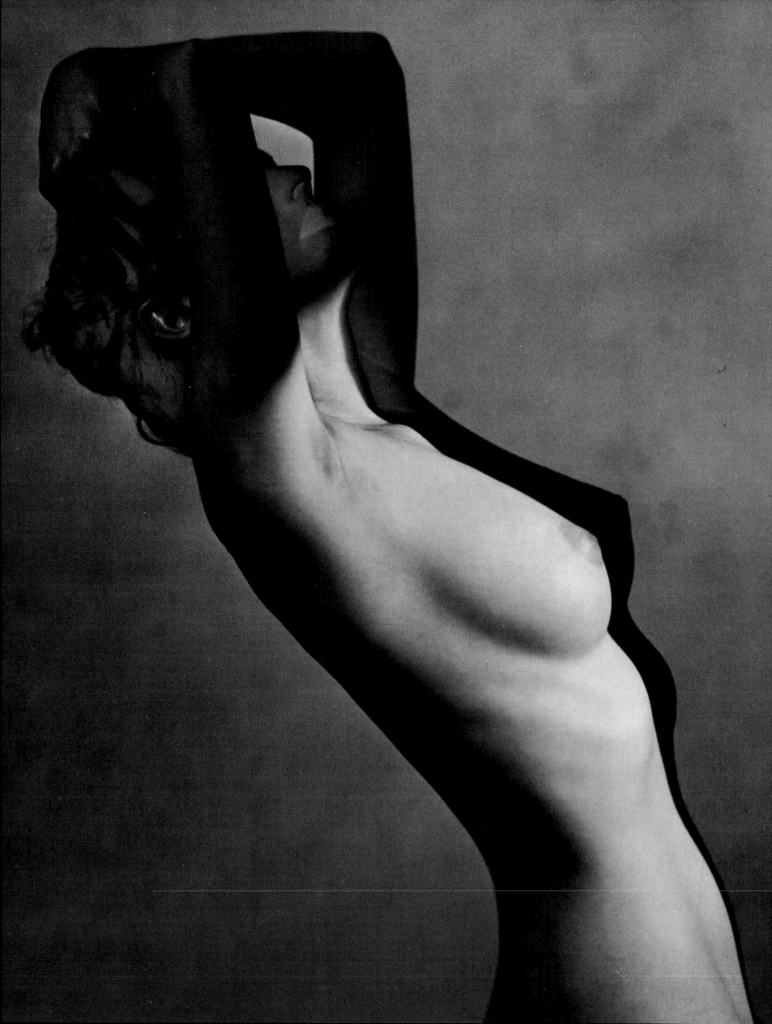

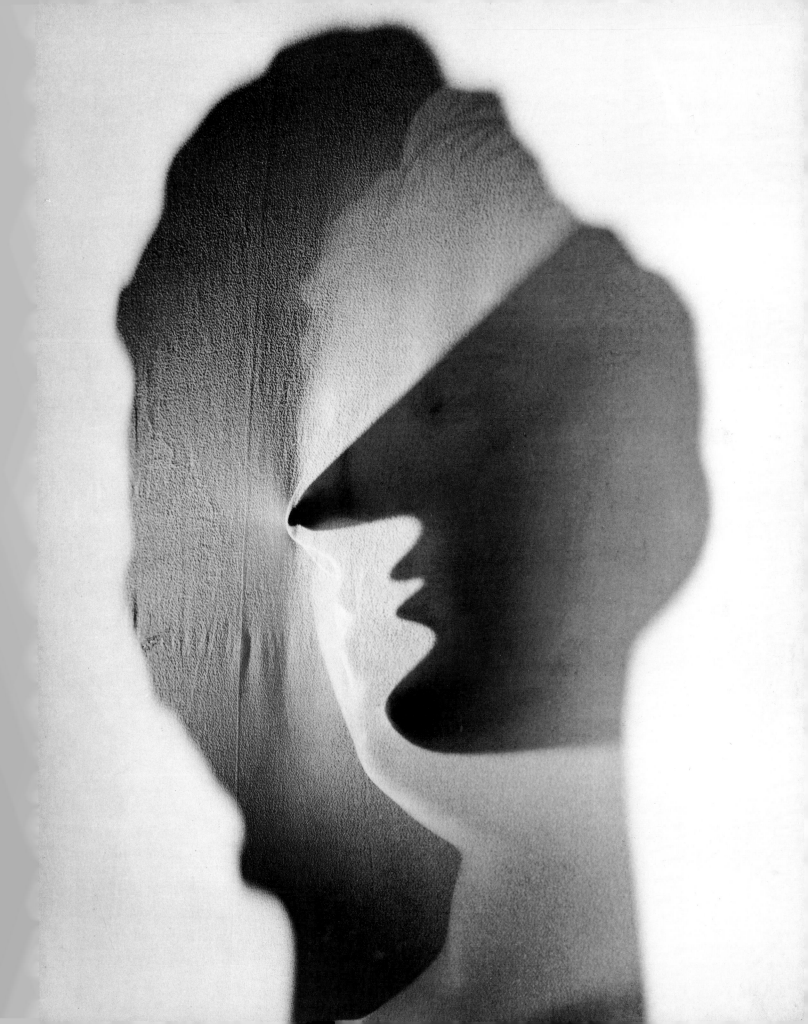

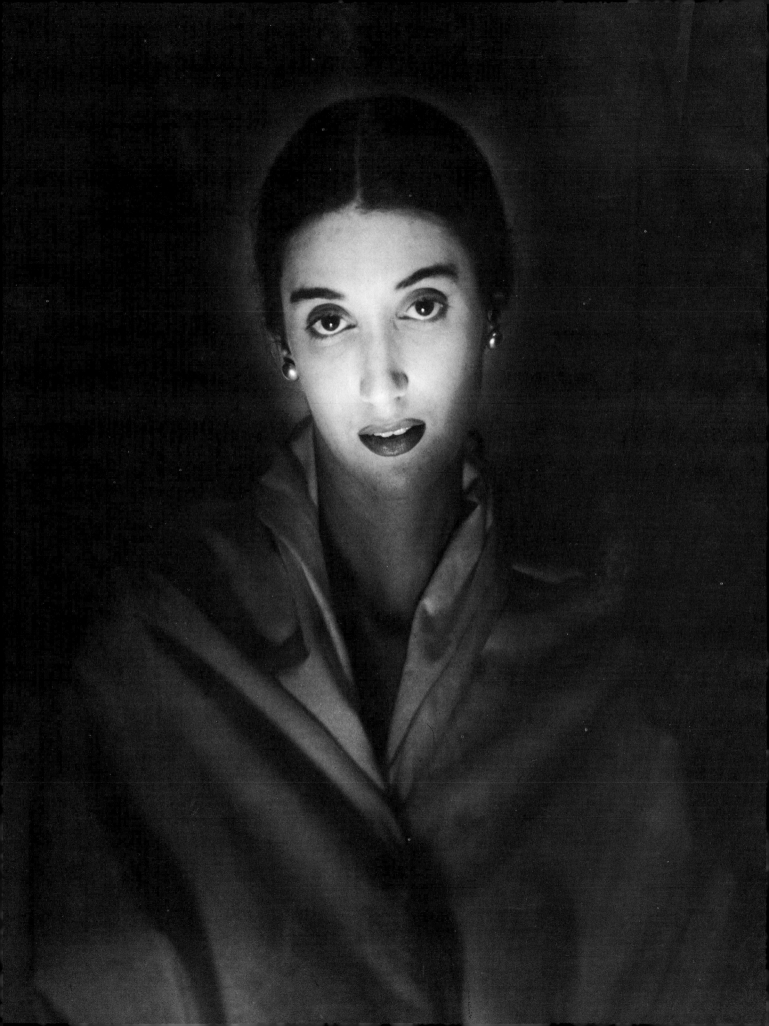

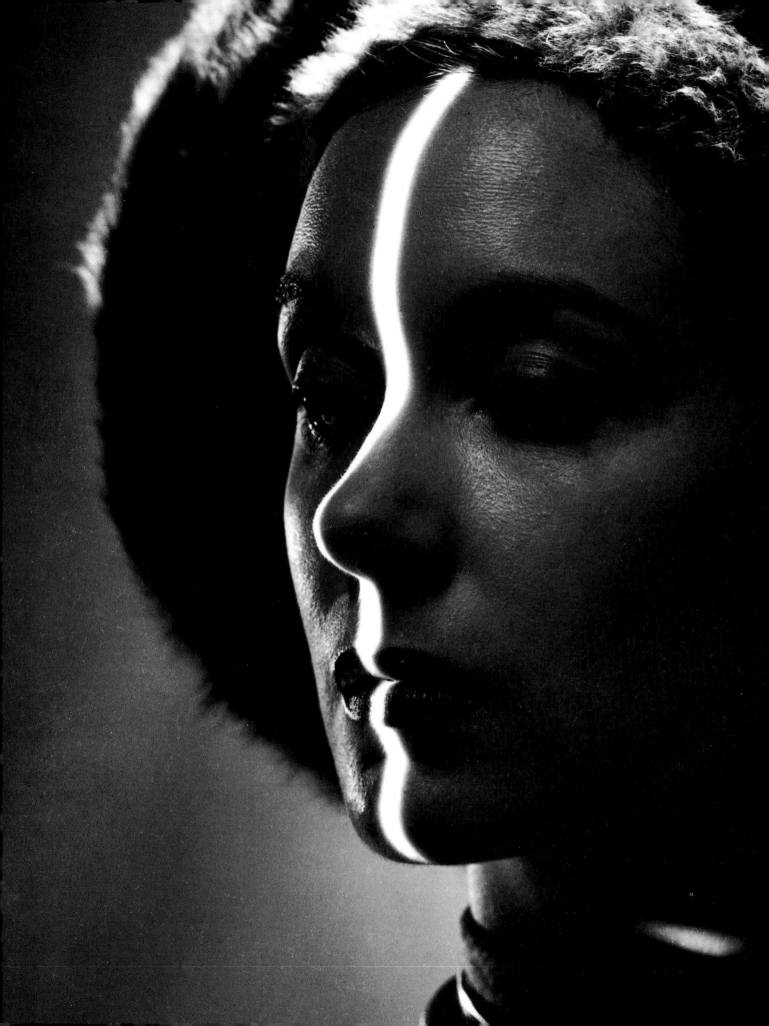

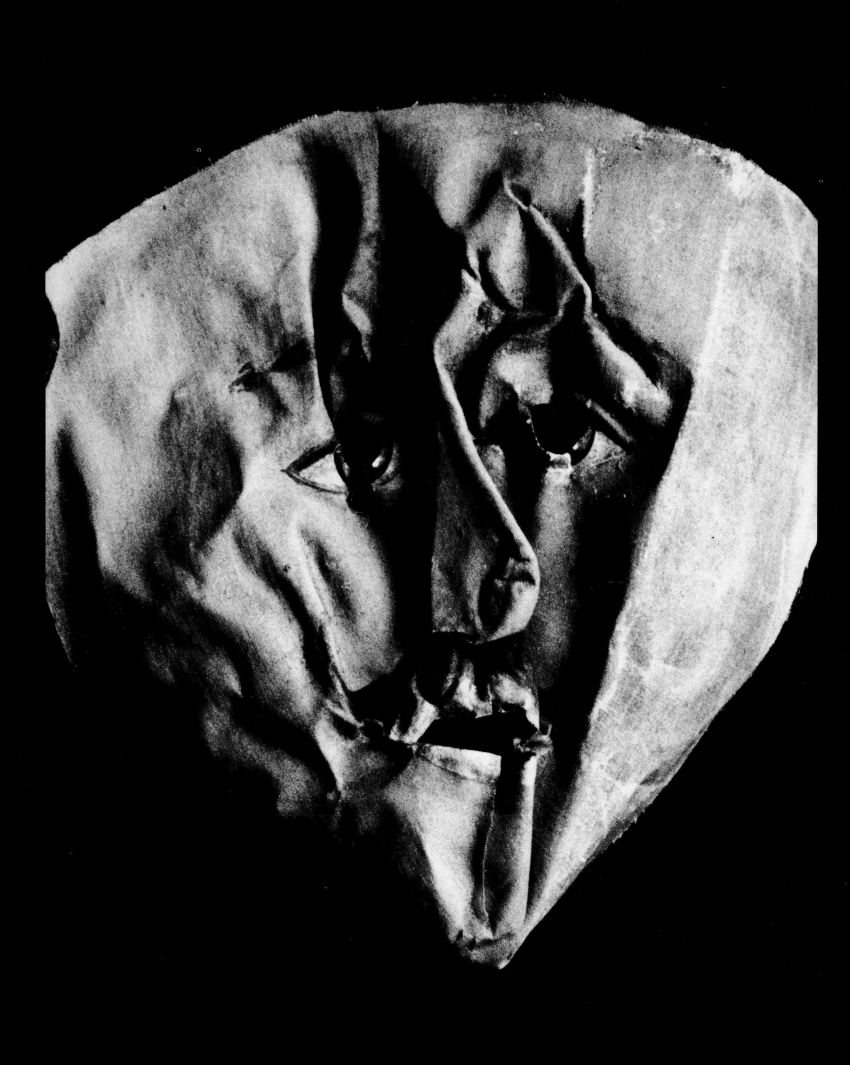

51

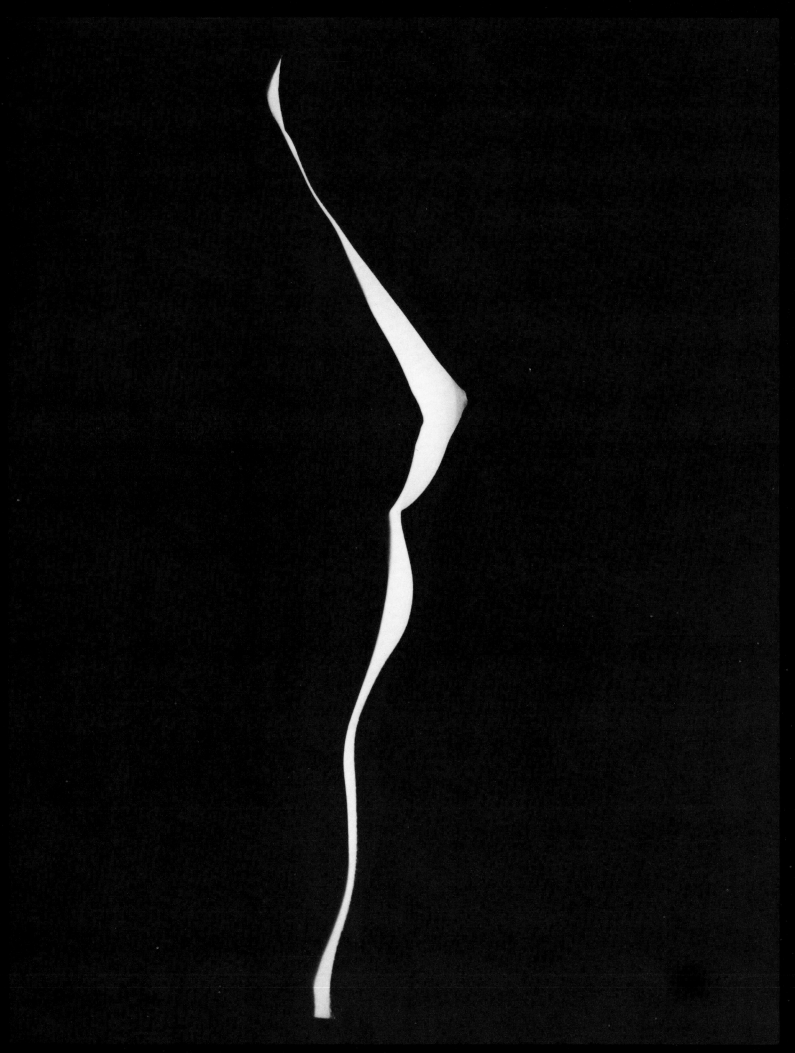

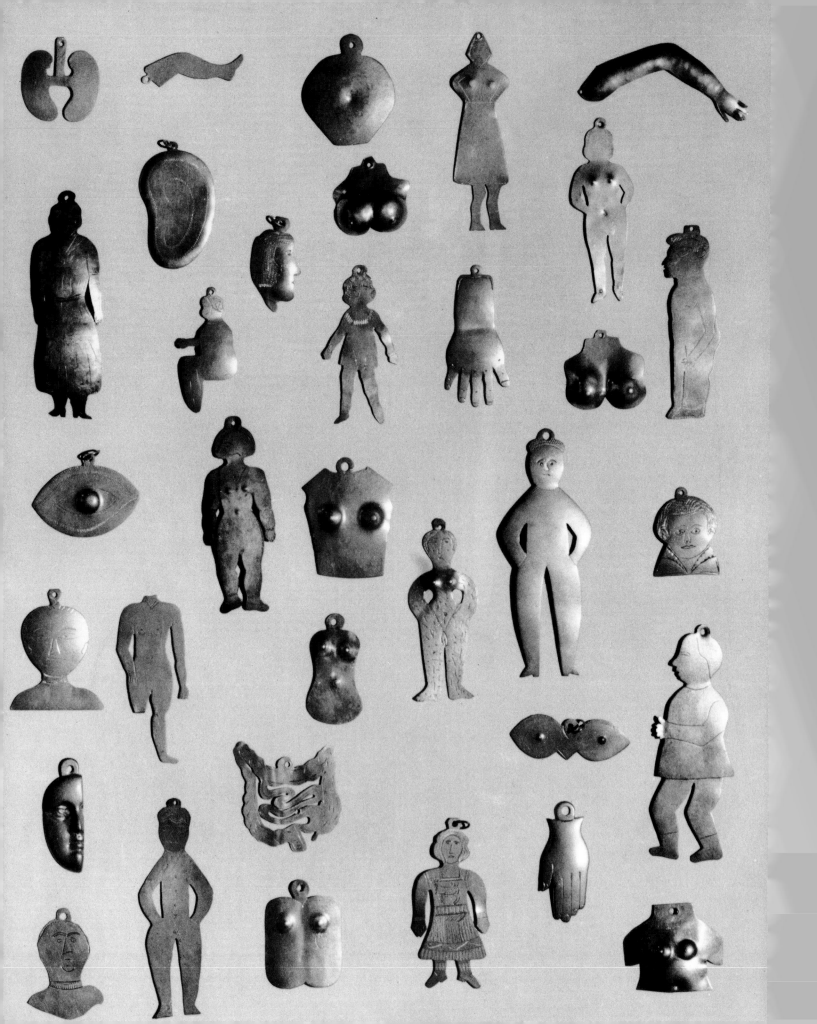

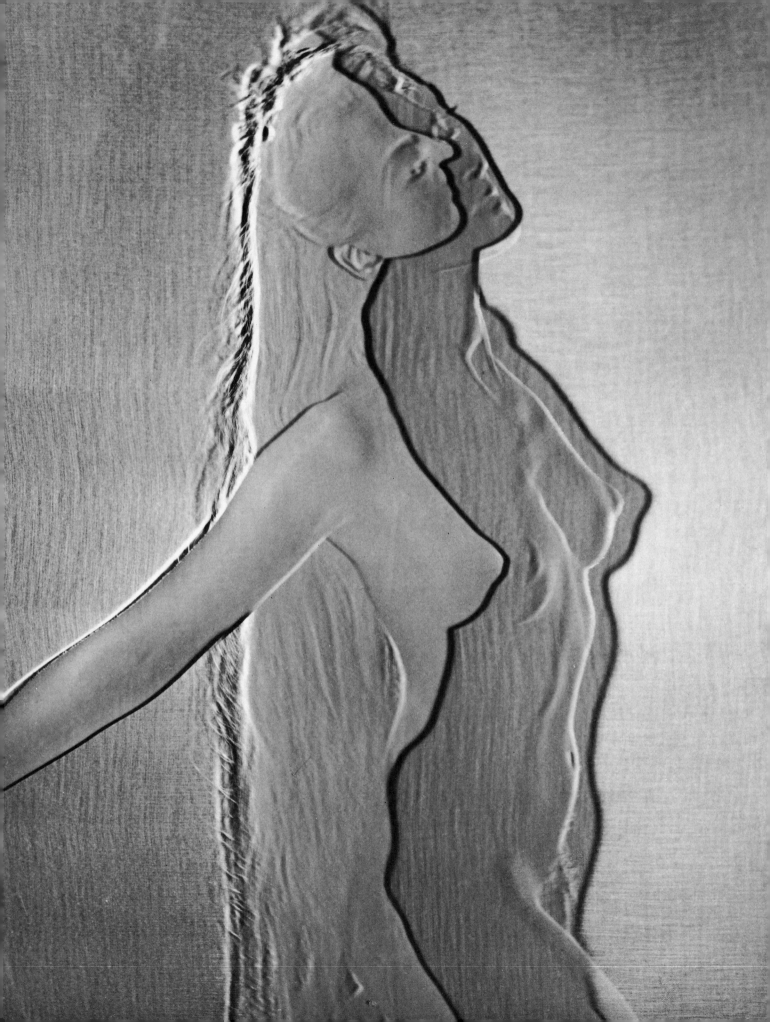

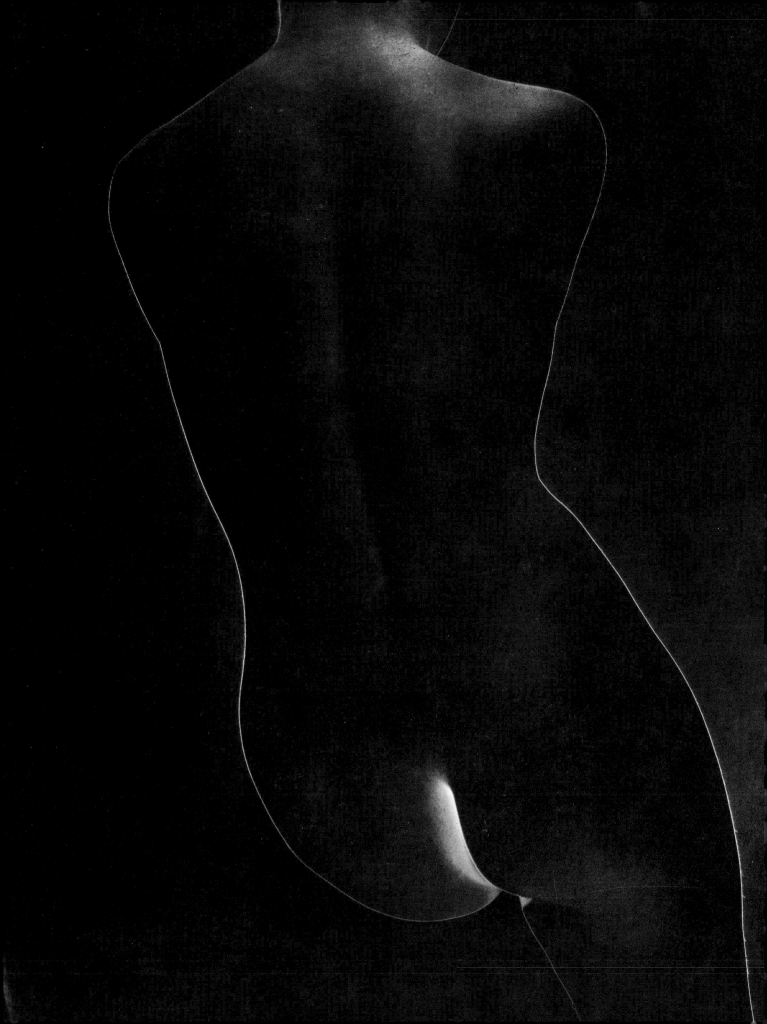

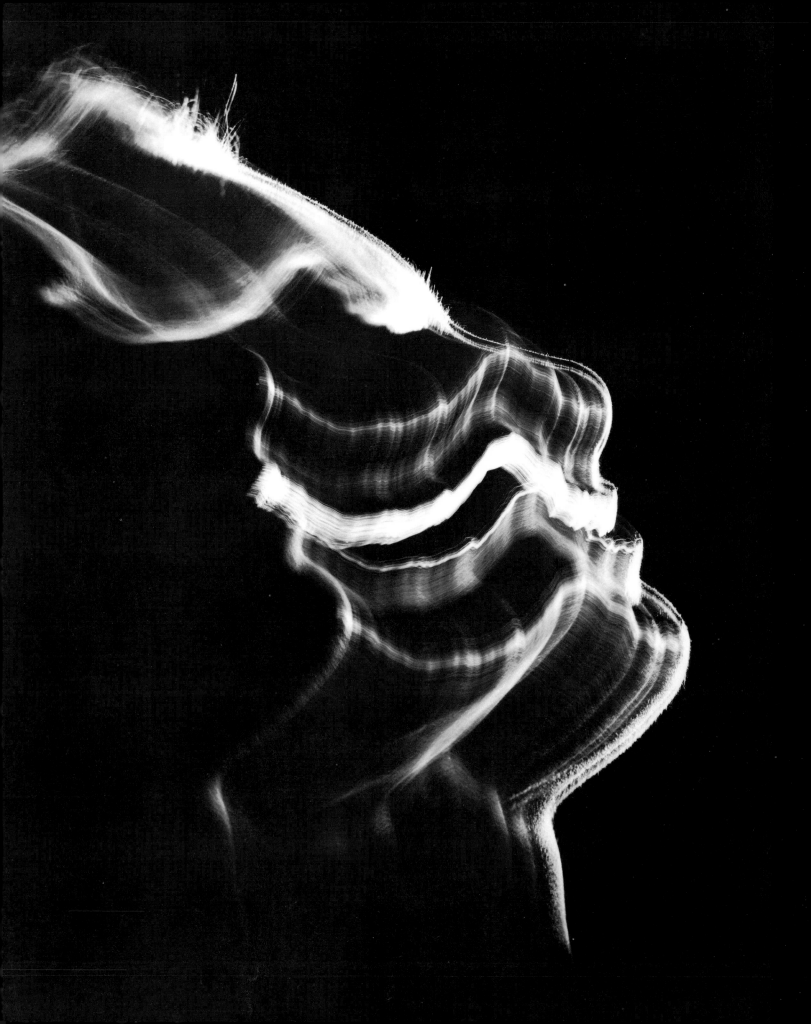

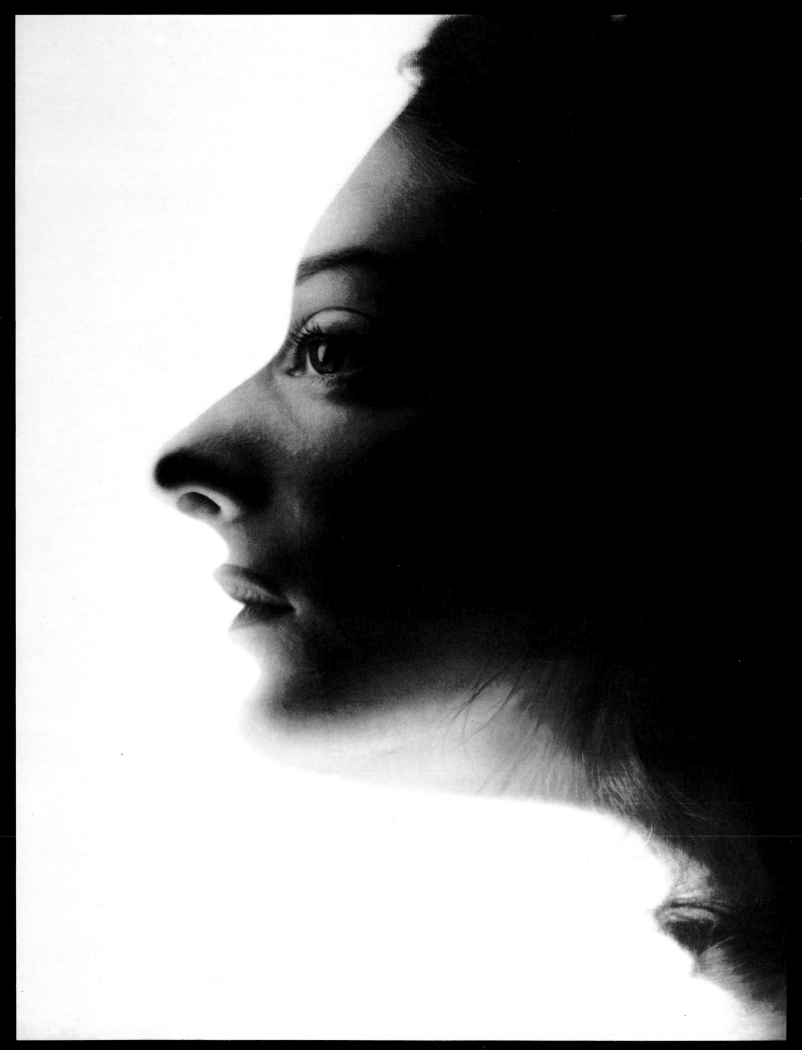

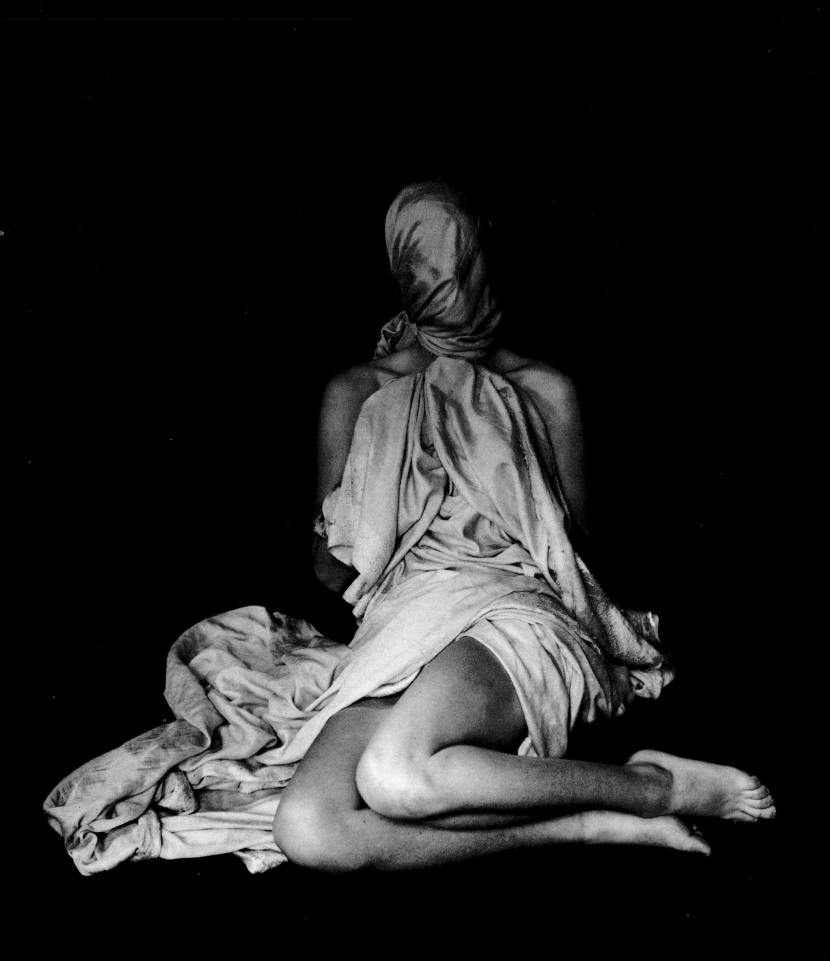

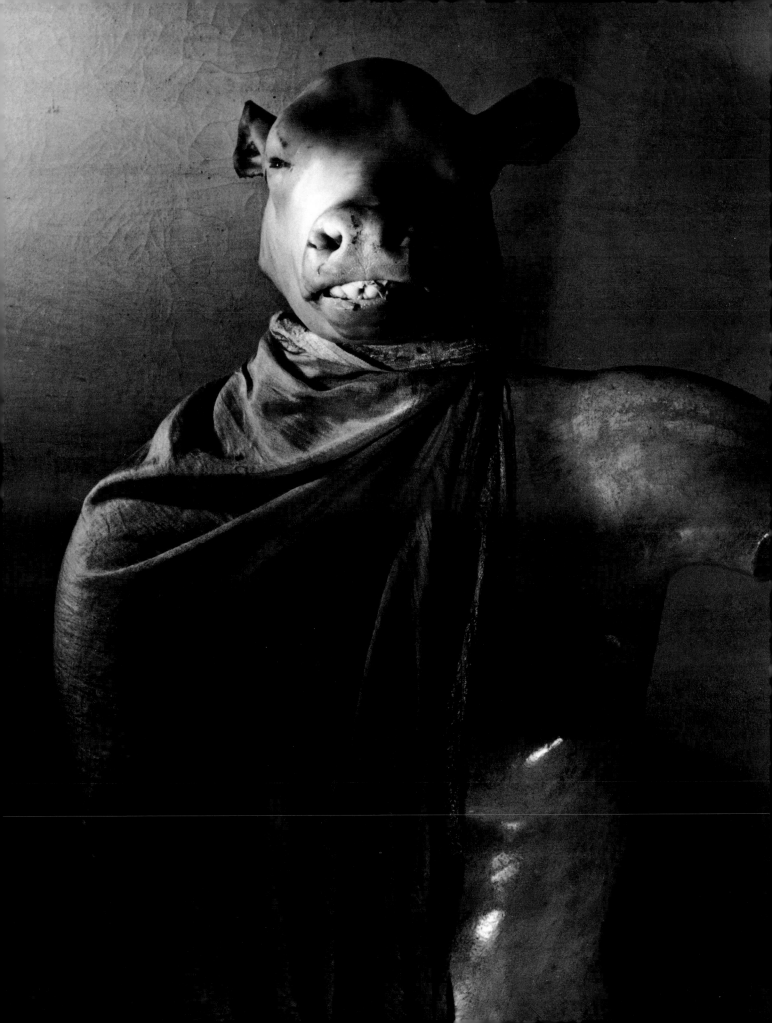

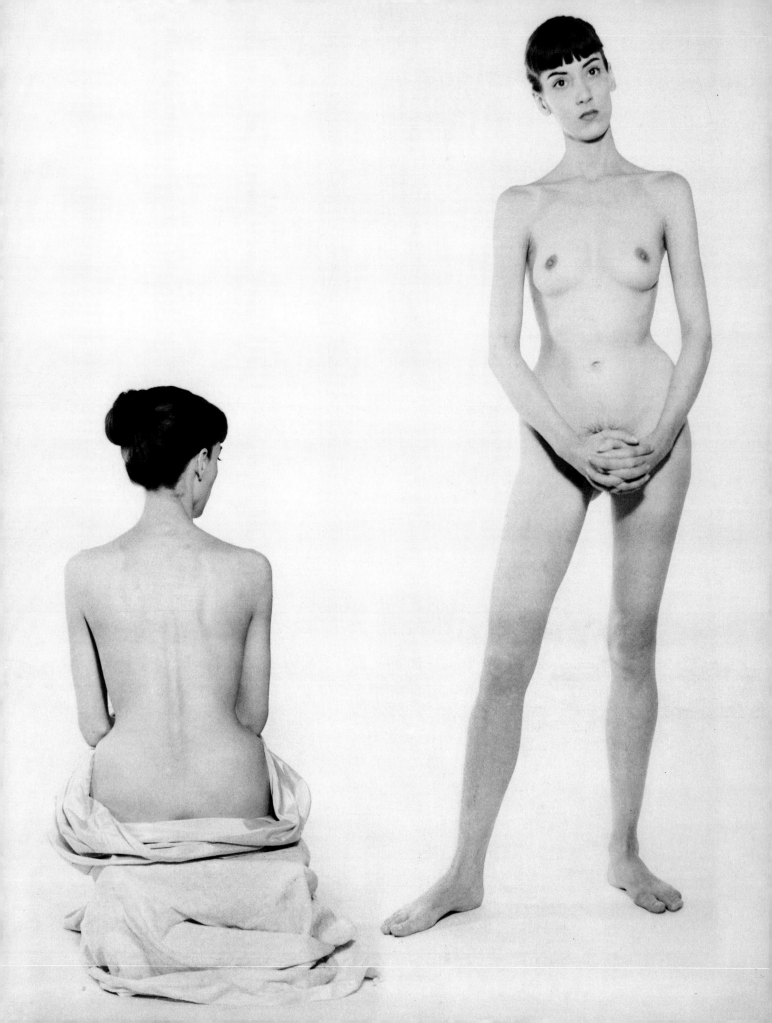

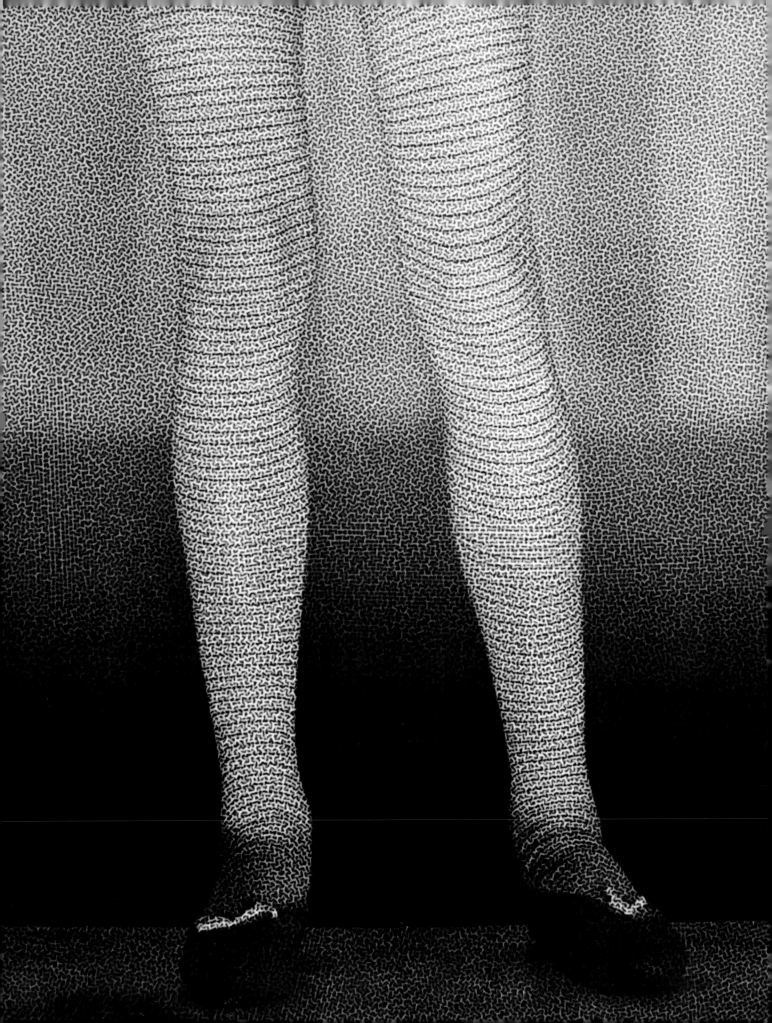

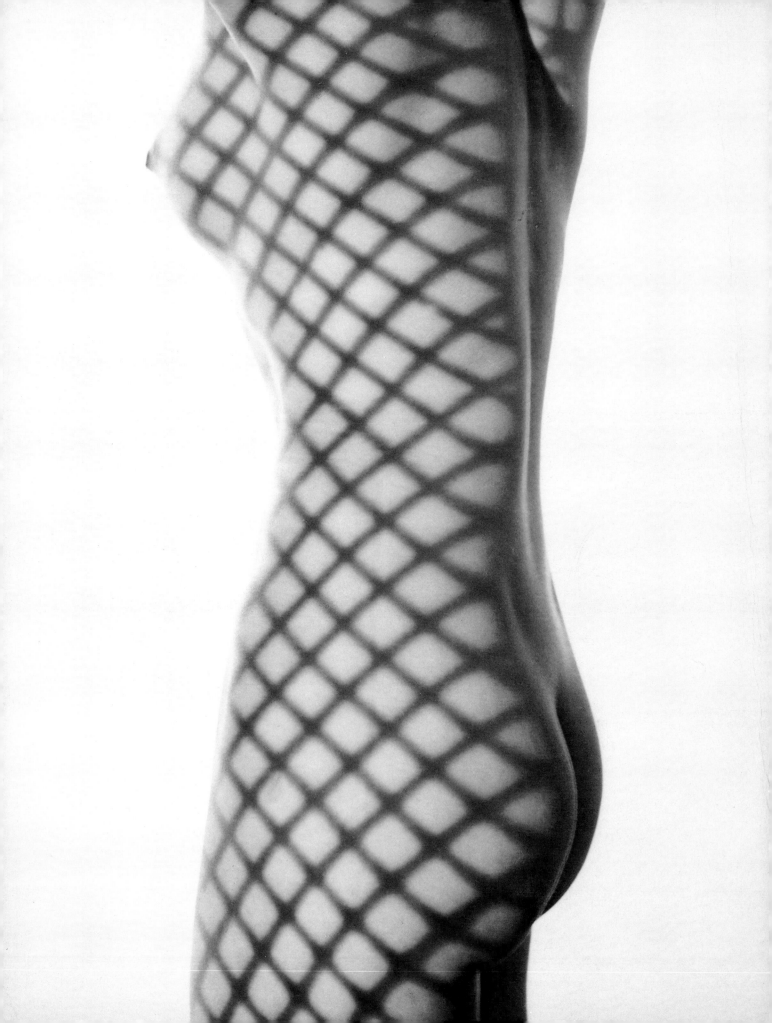

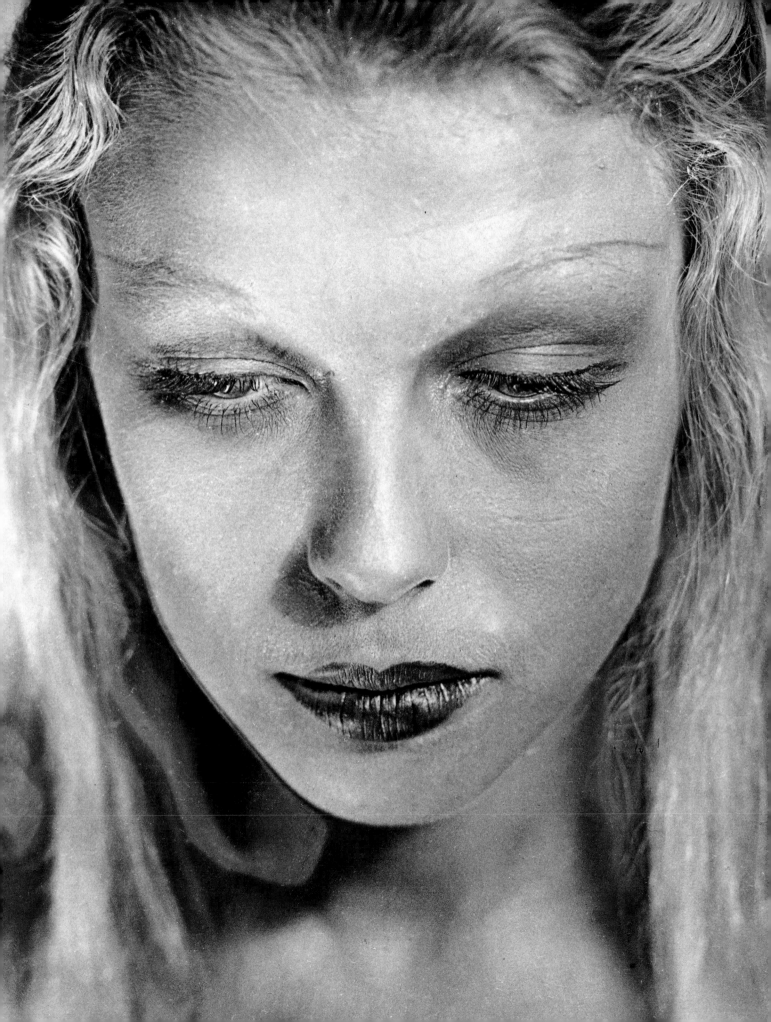

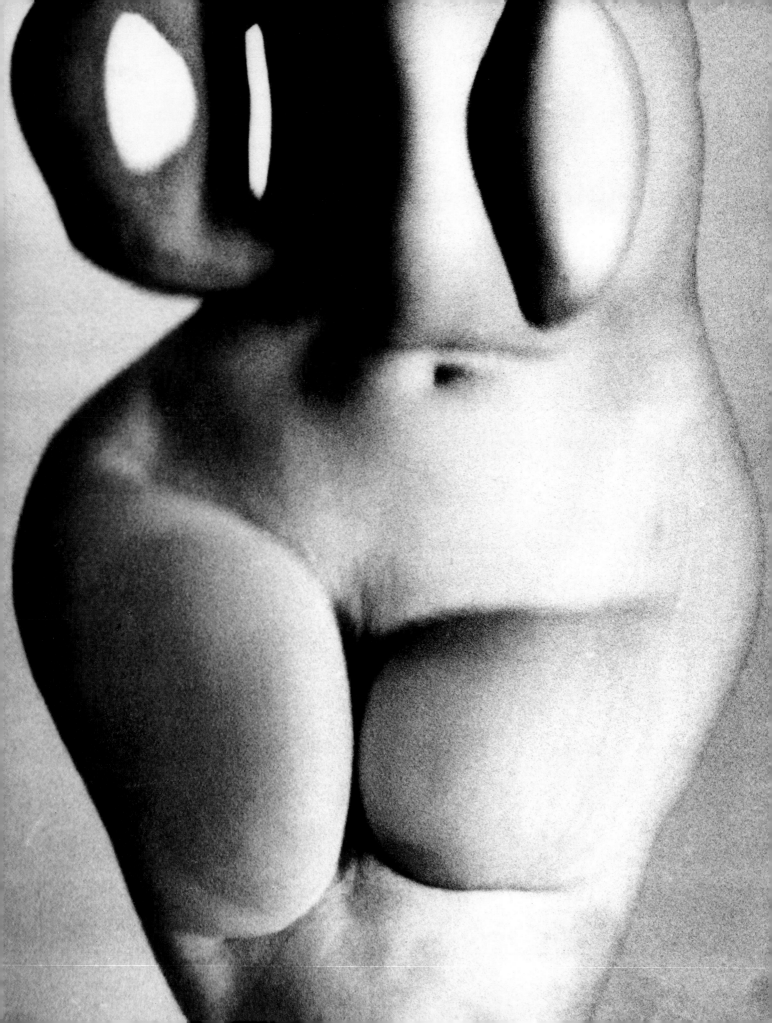

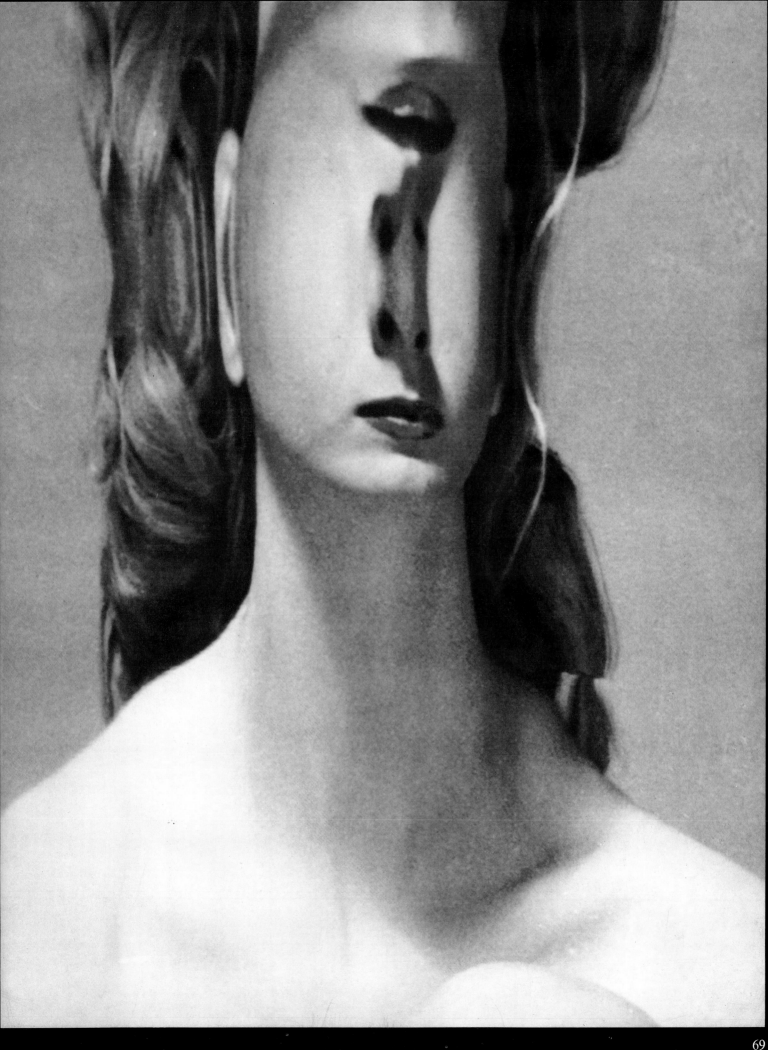

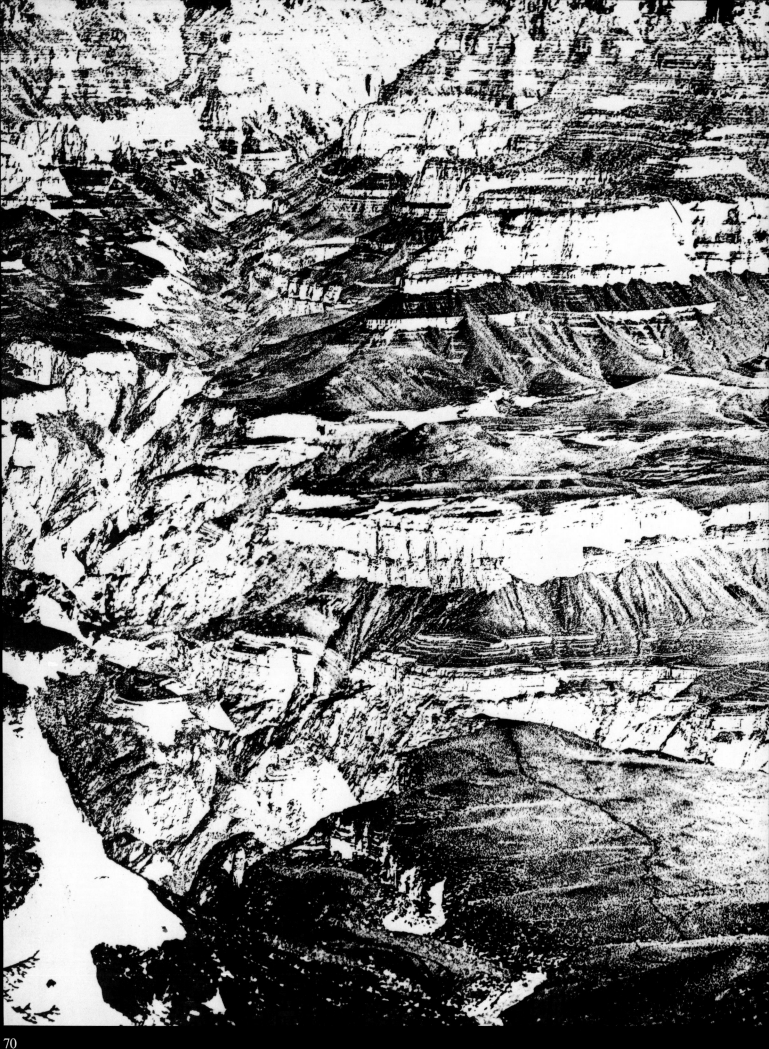

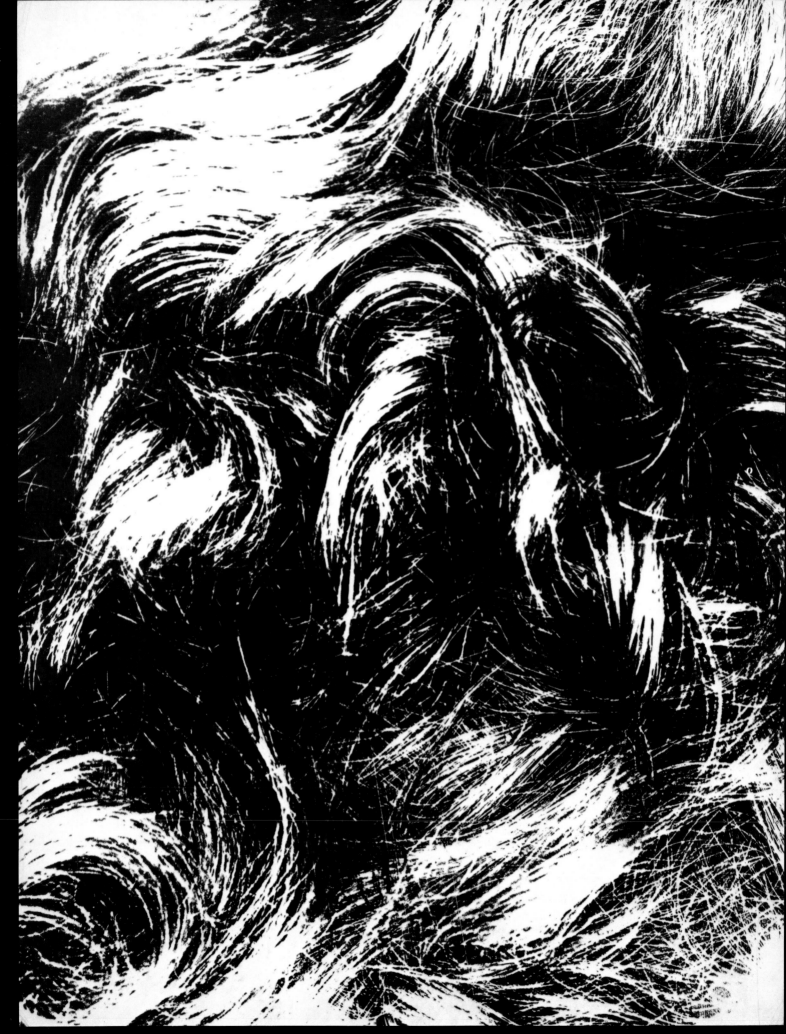

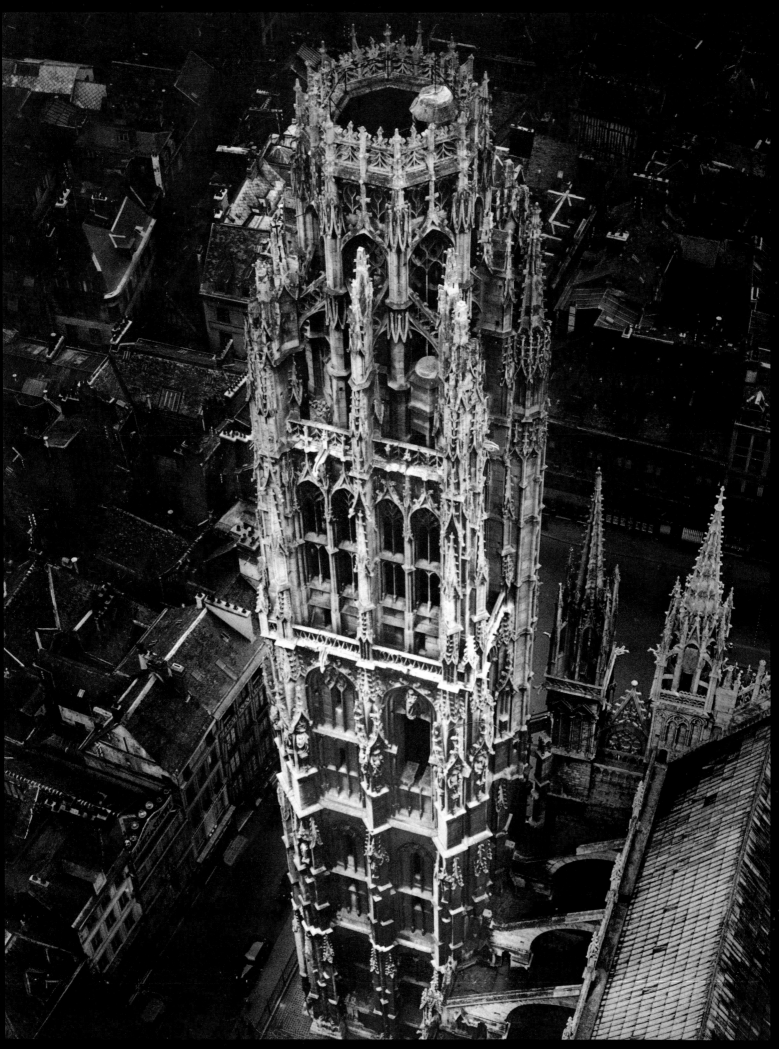

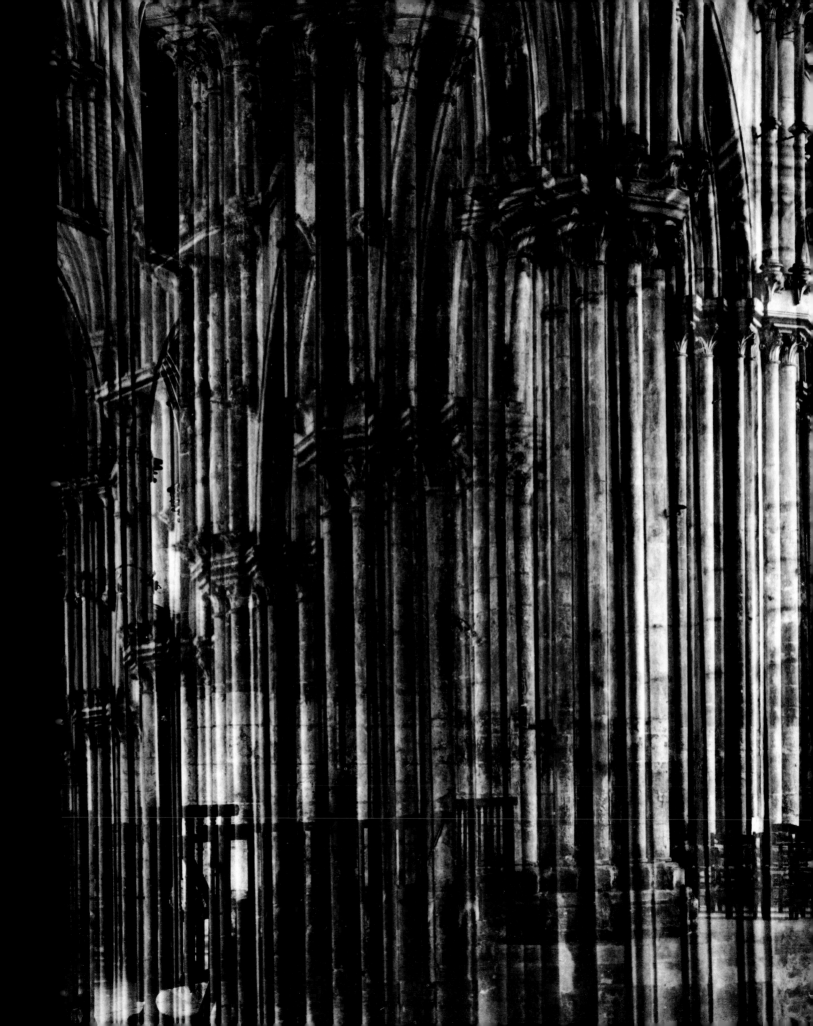

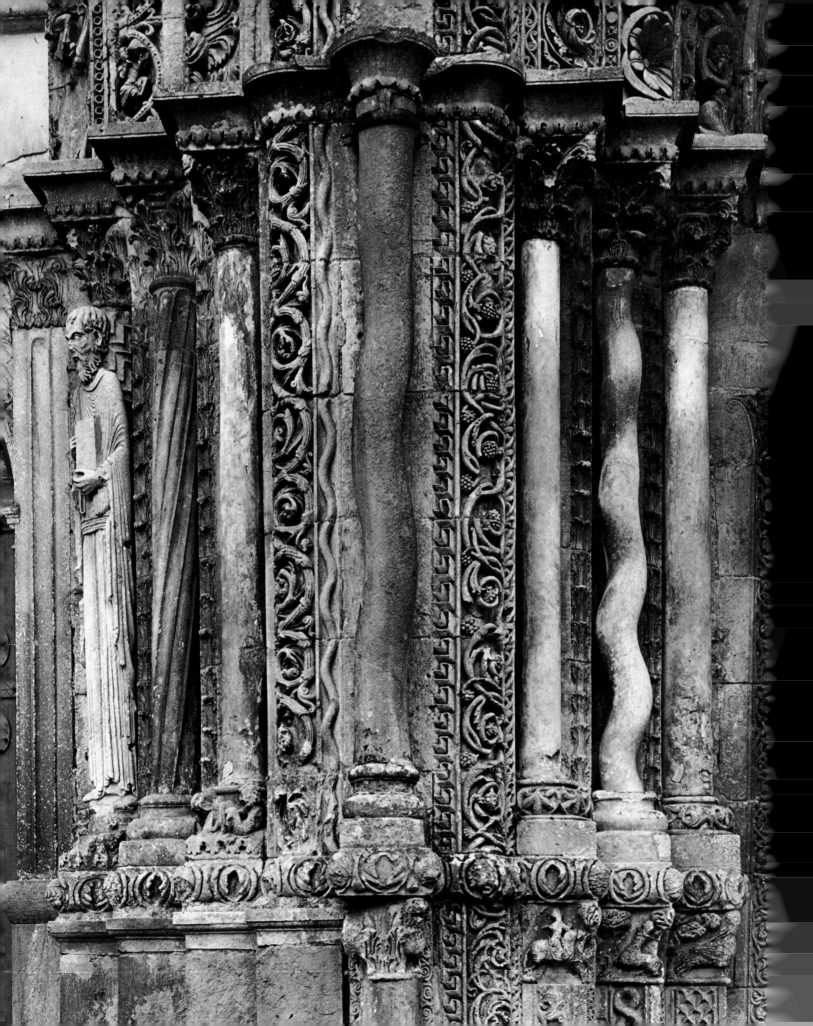

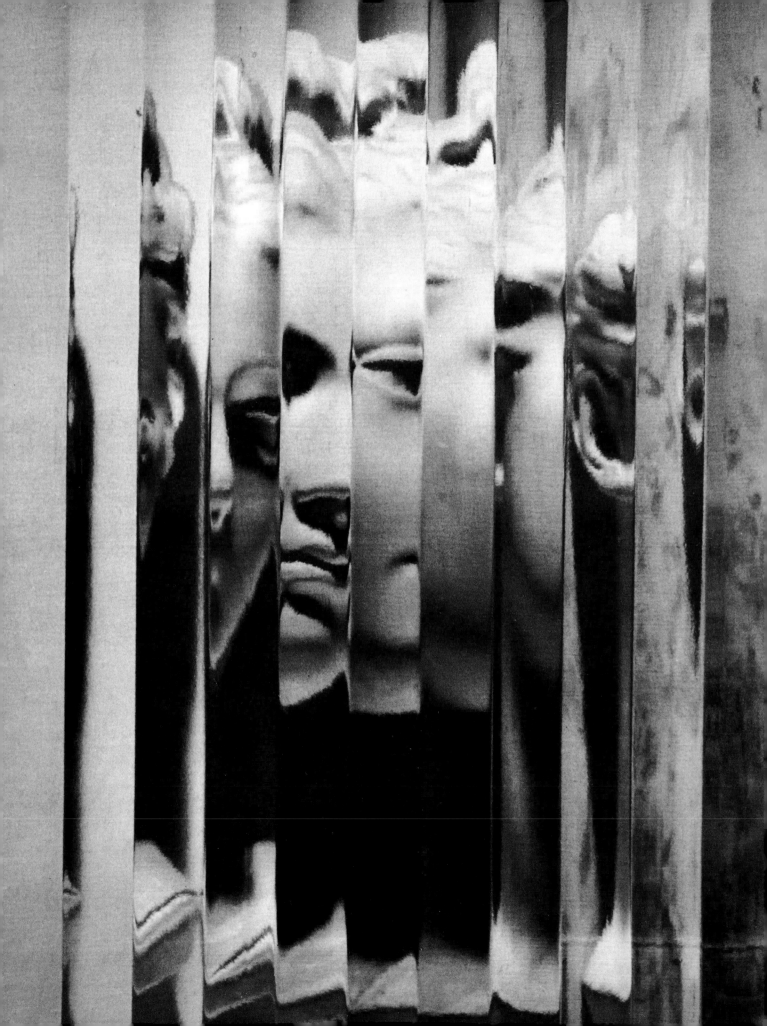

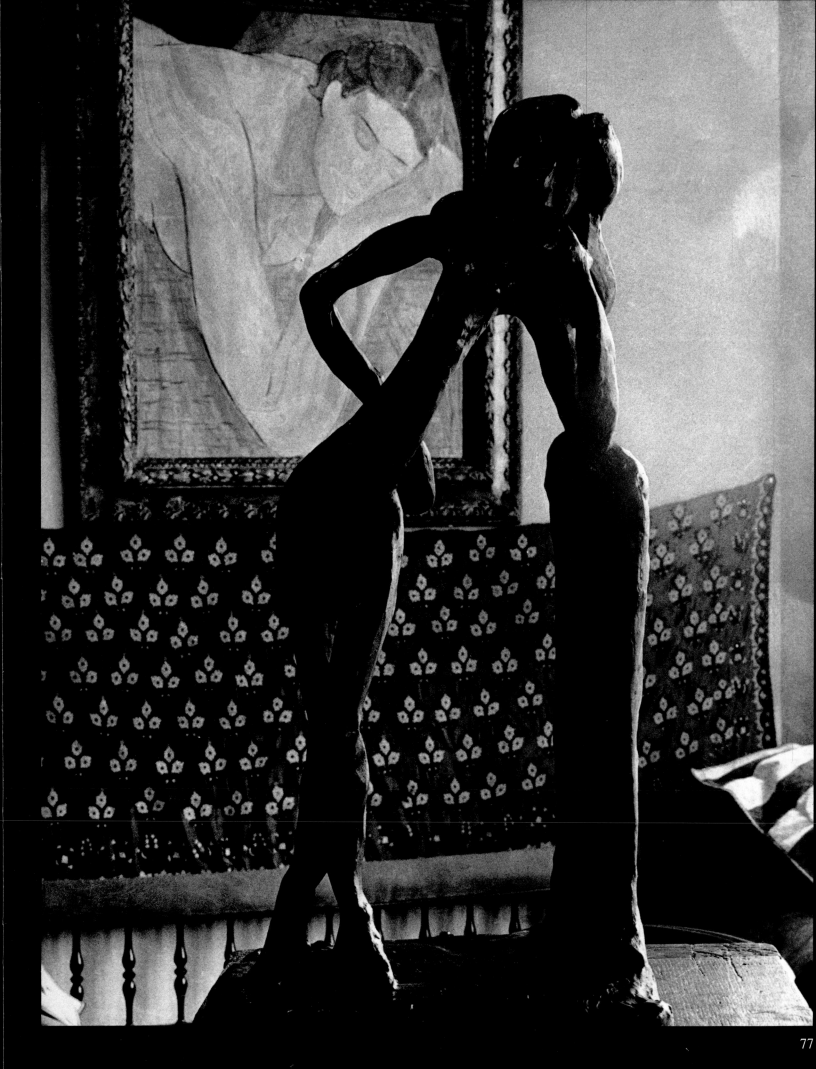

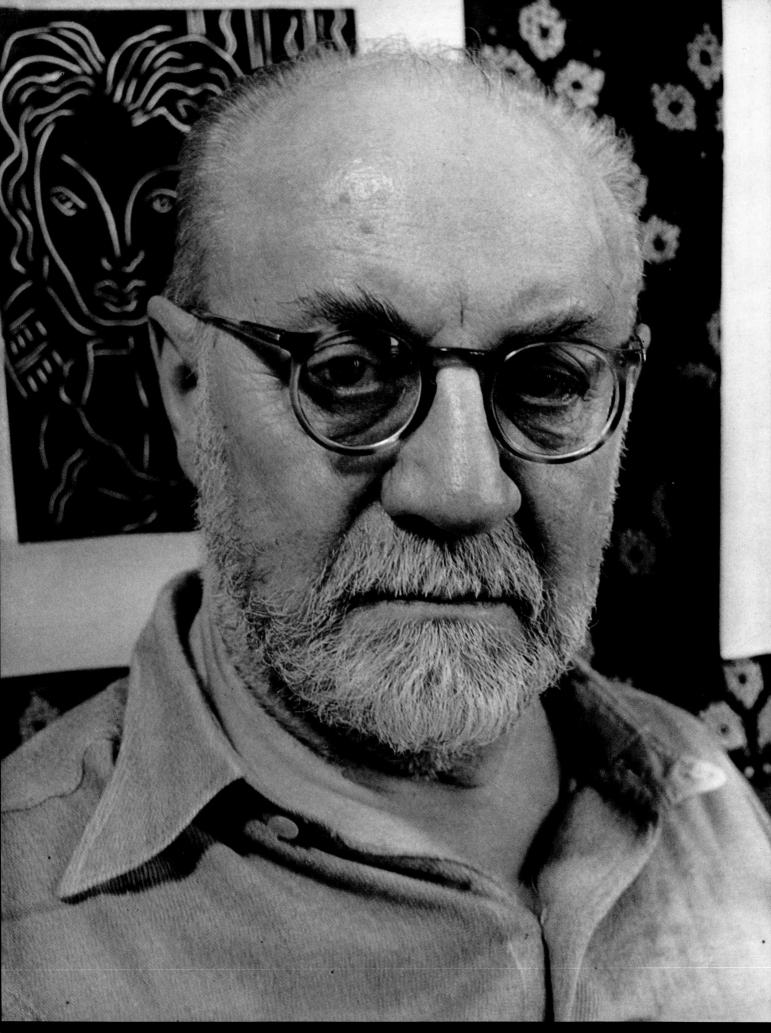

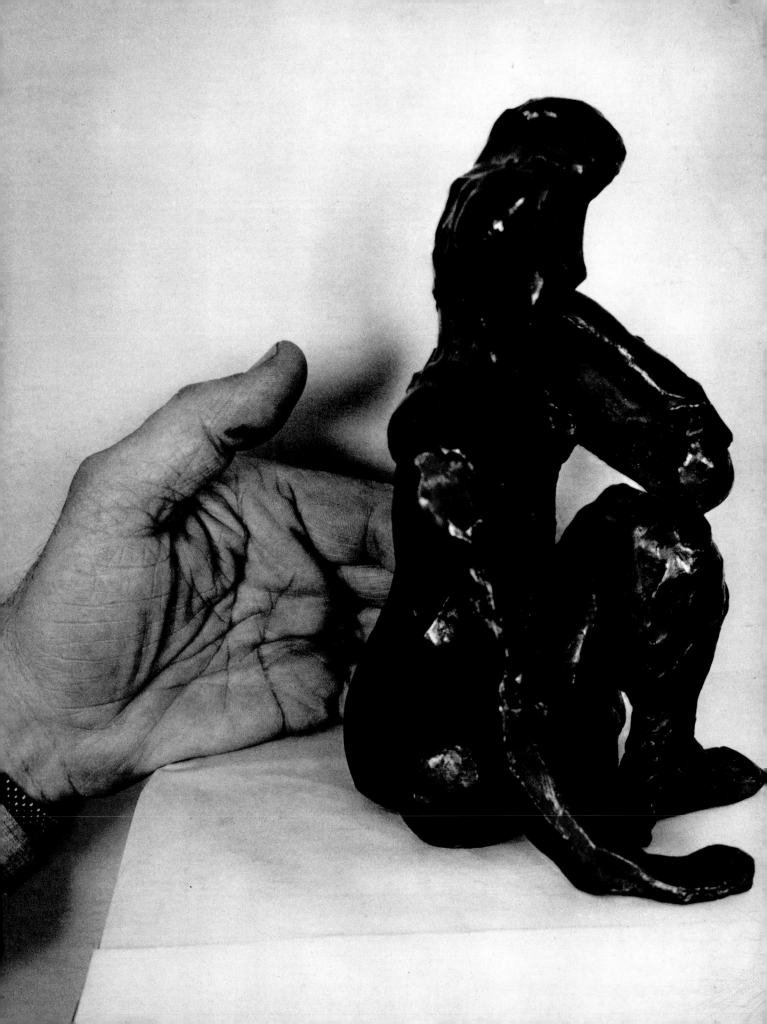

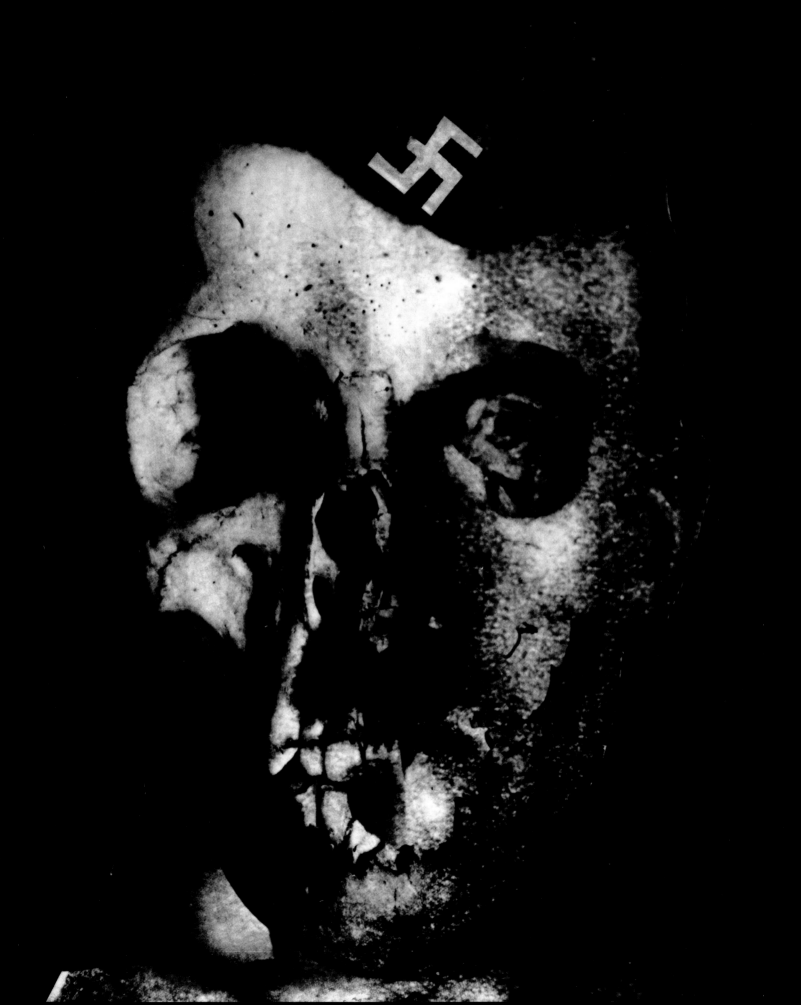

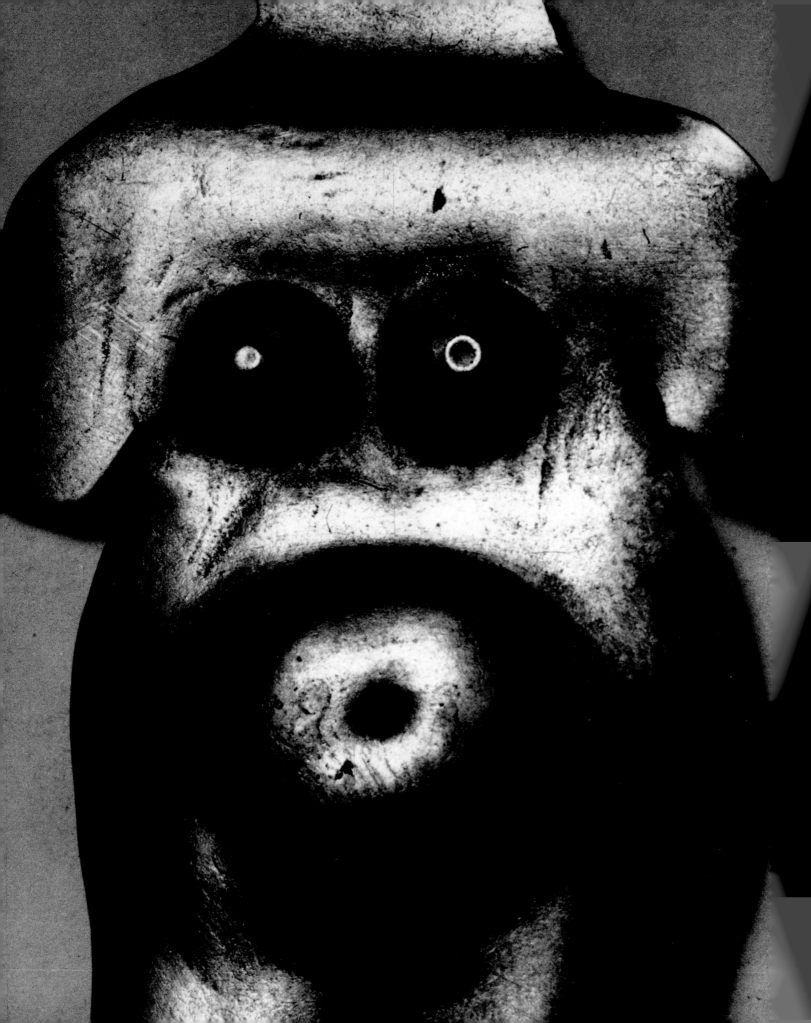

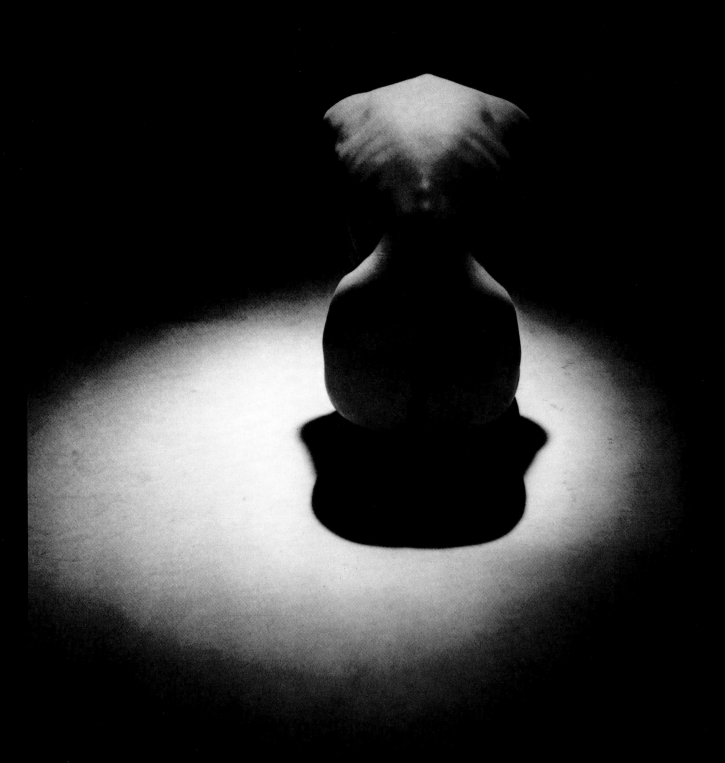

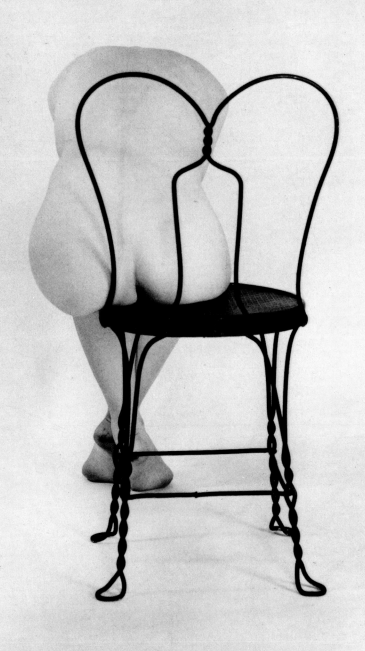

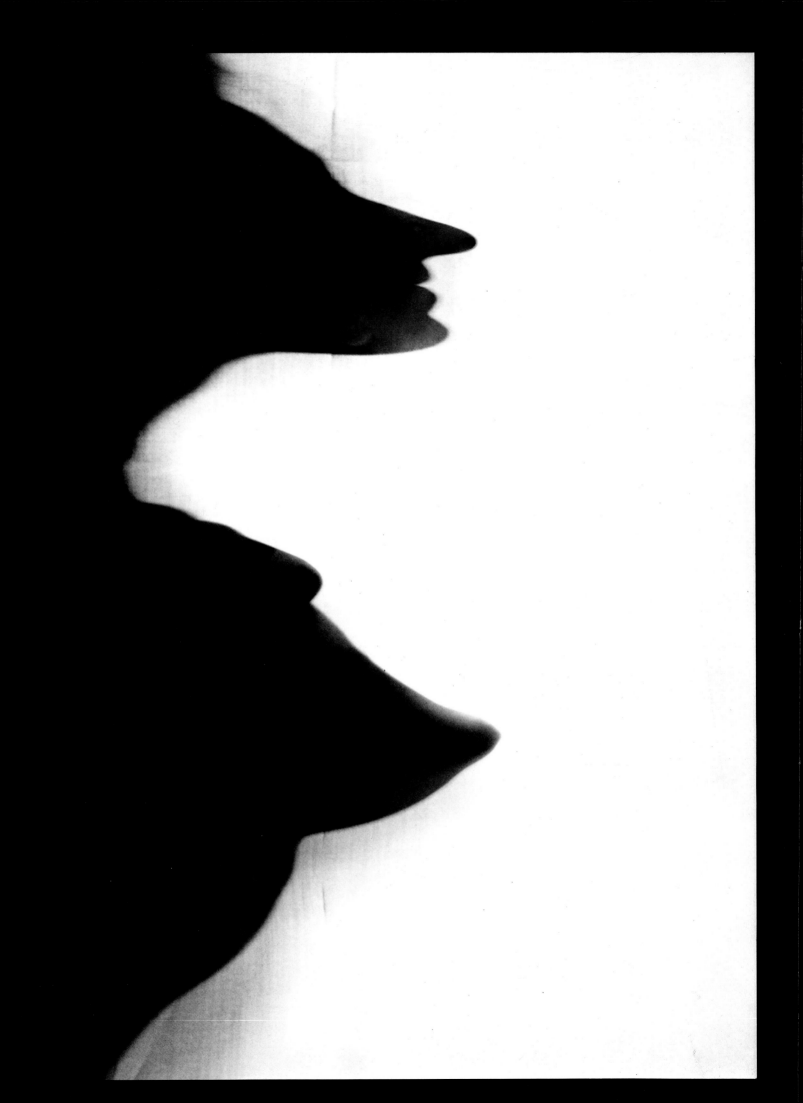

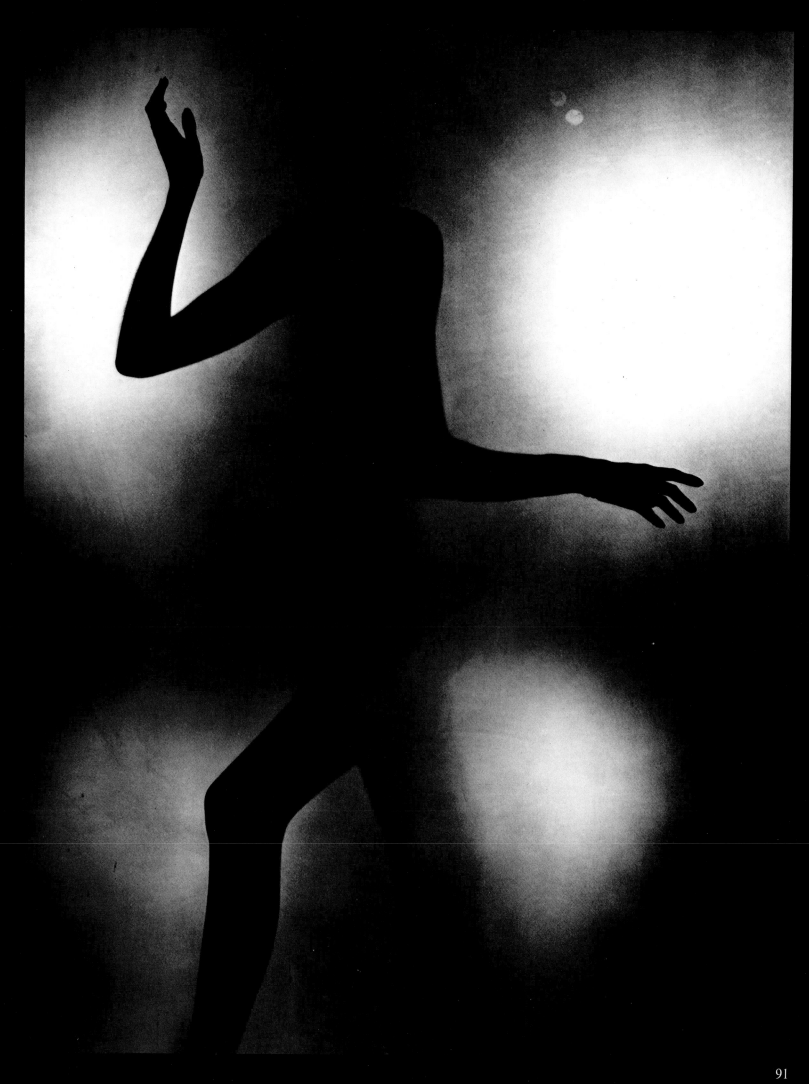

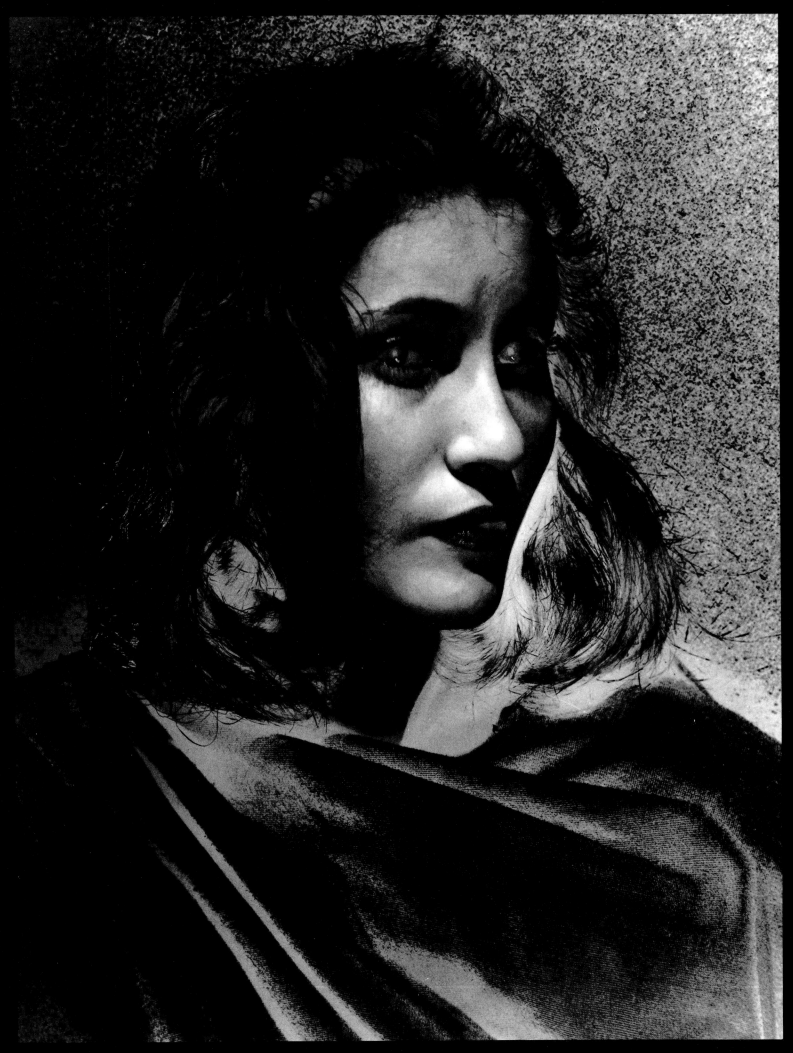

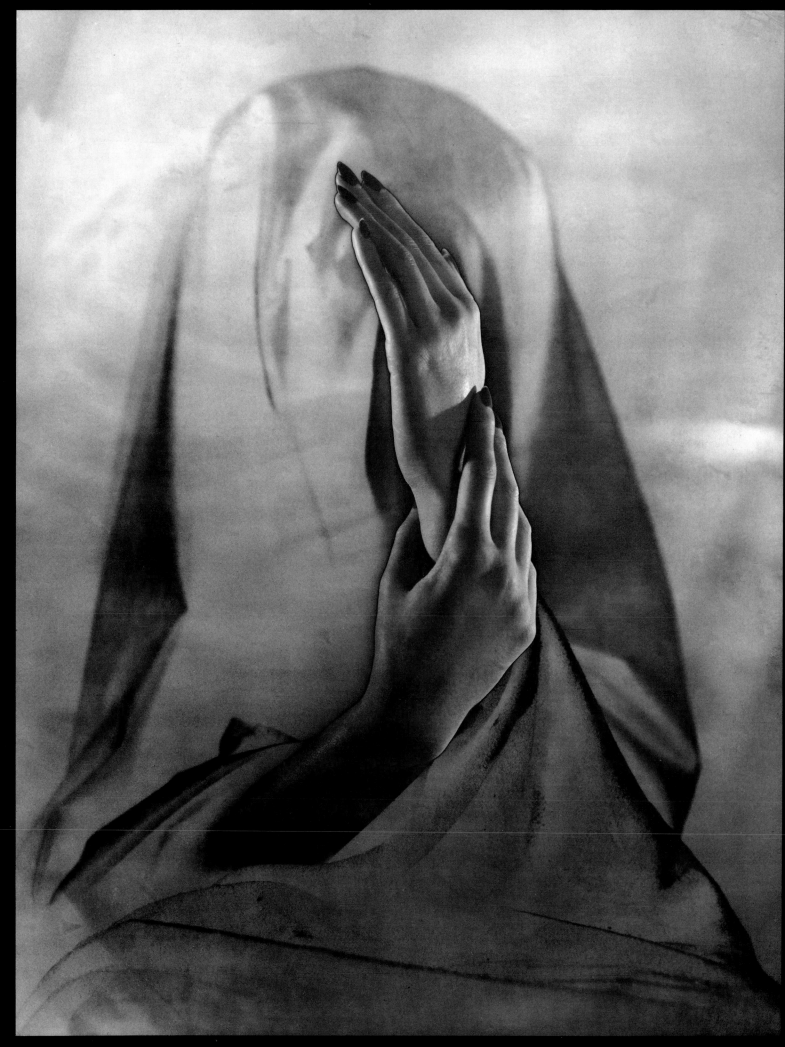

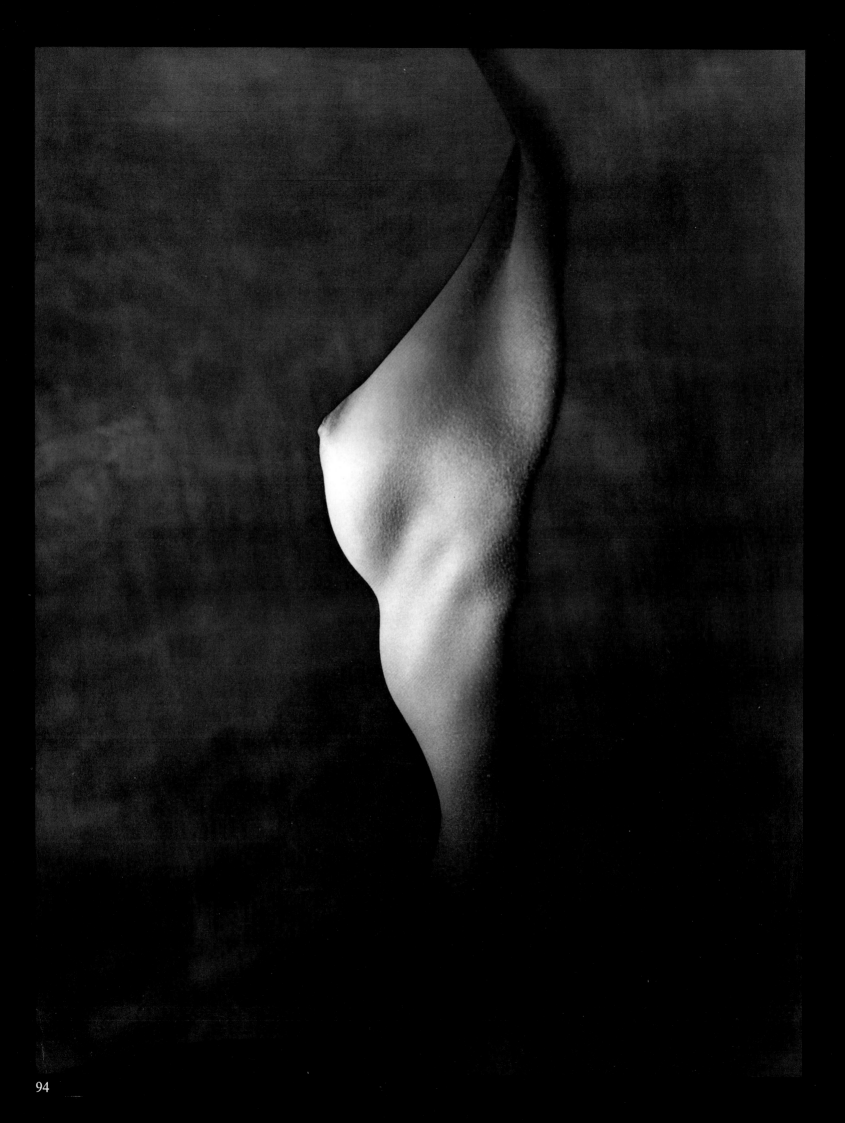

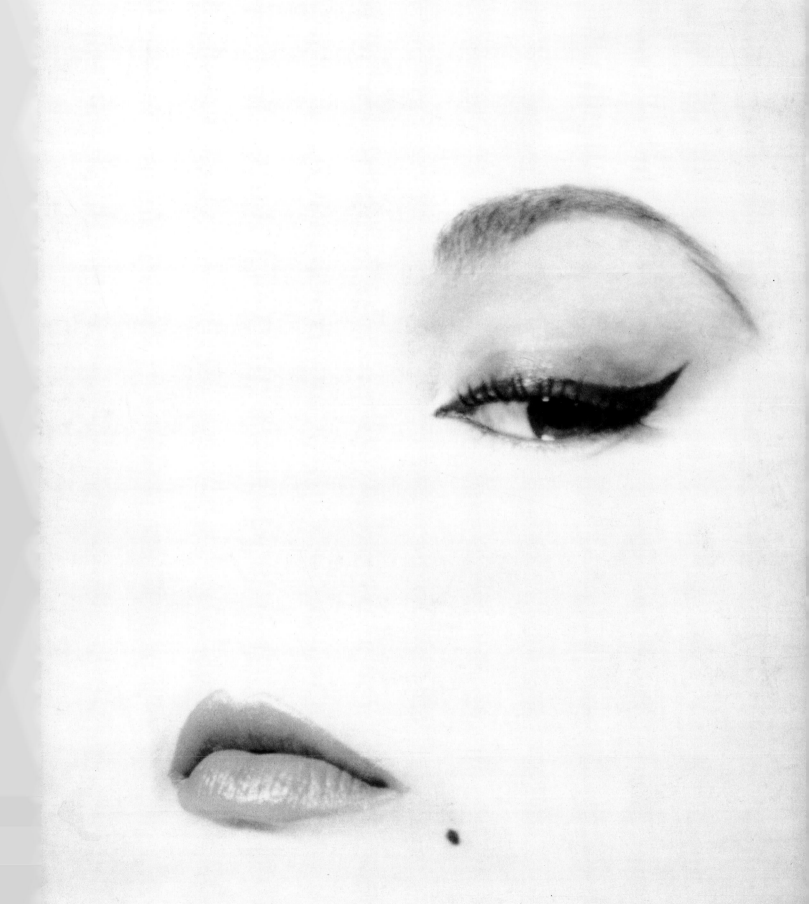

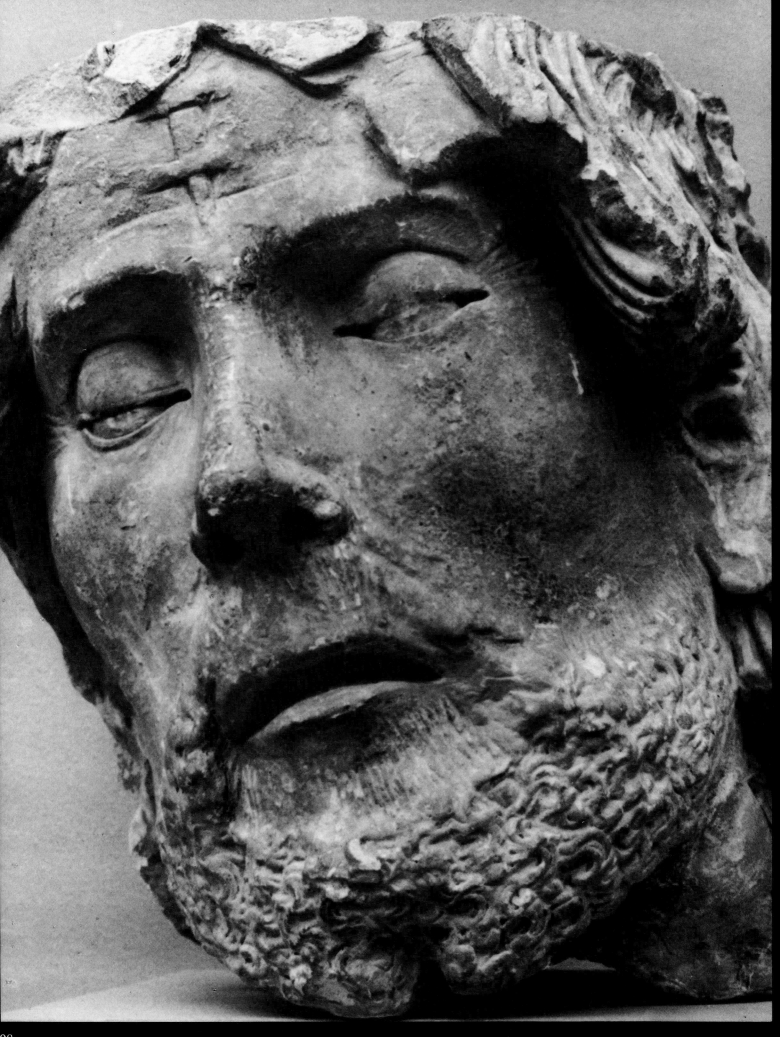

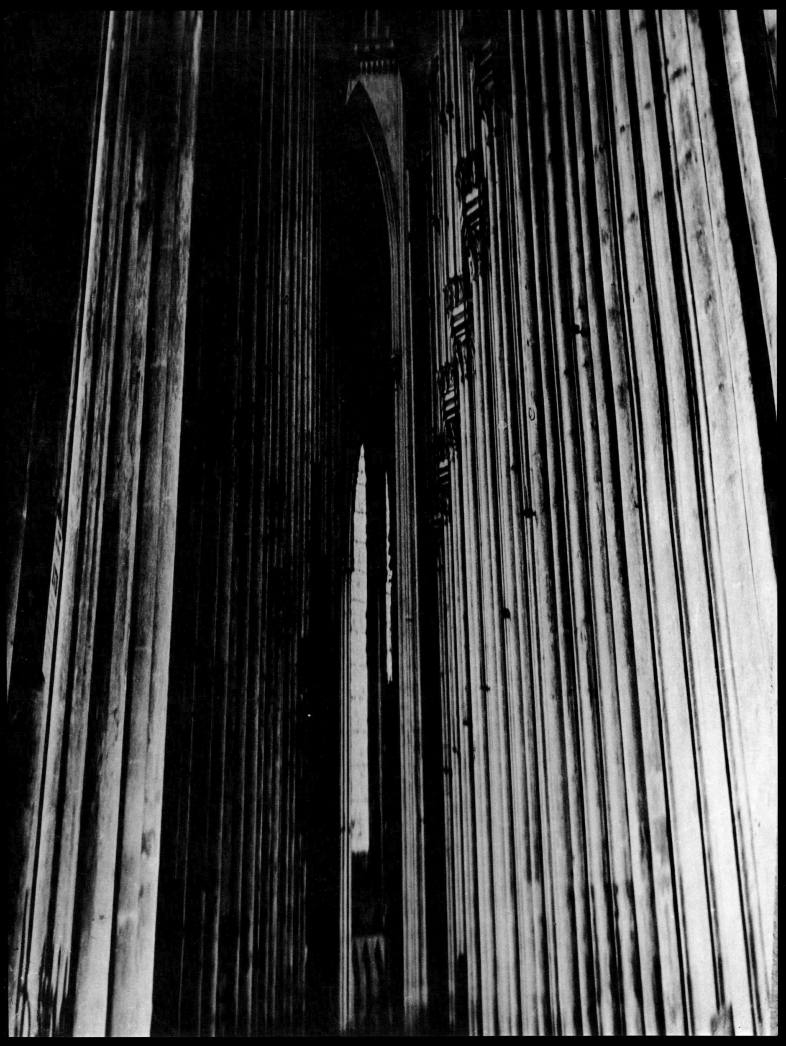

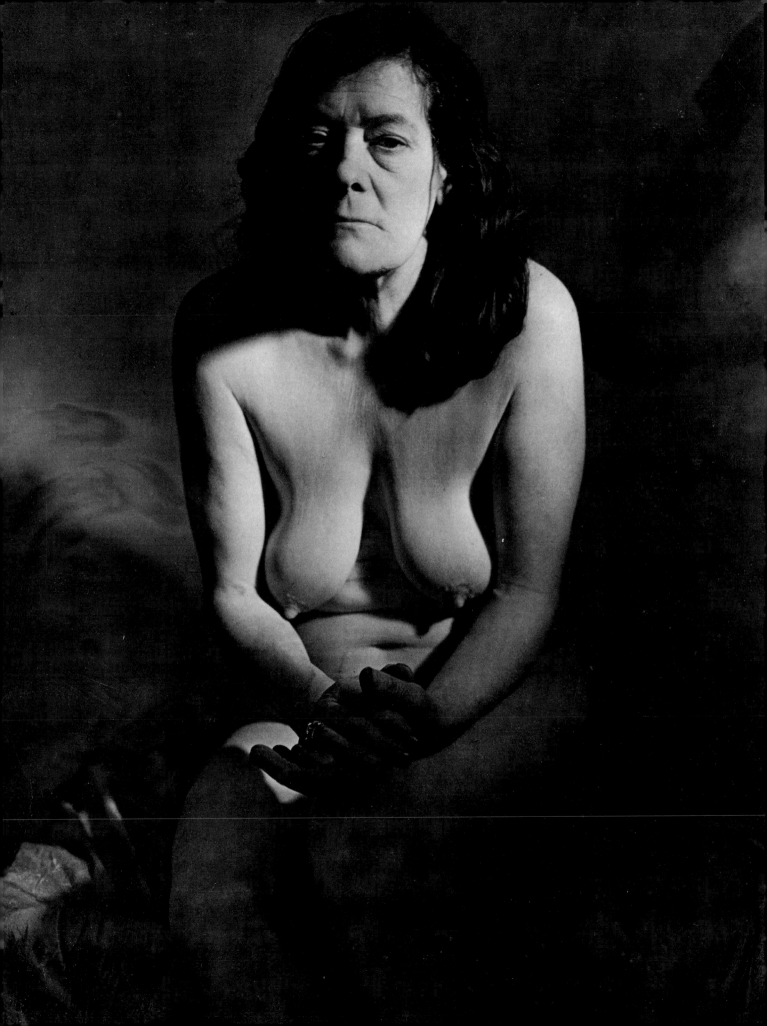

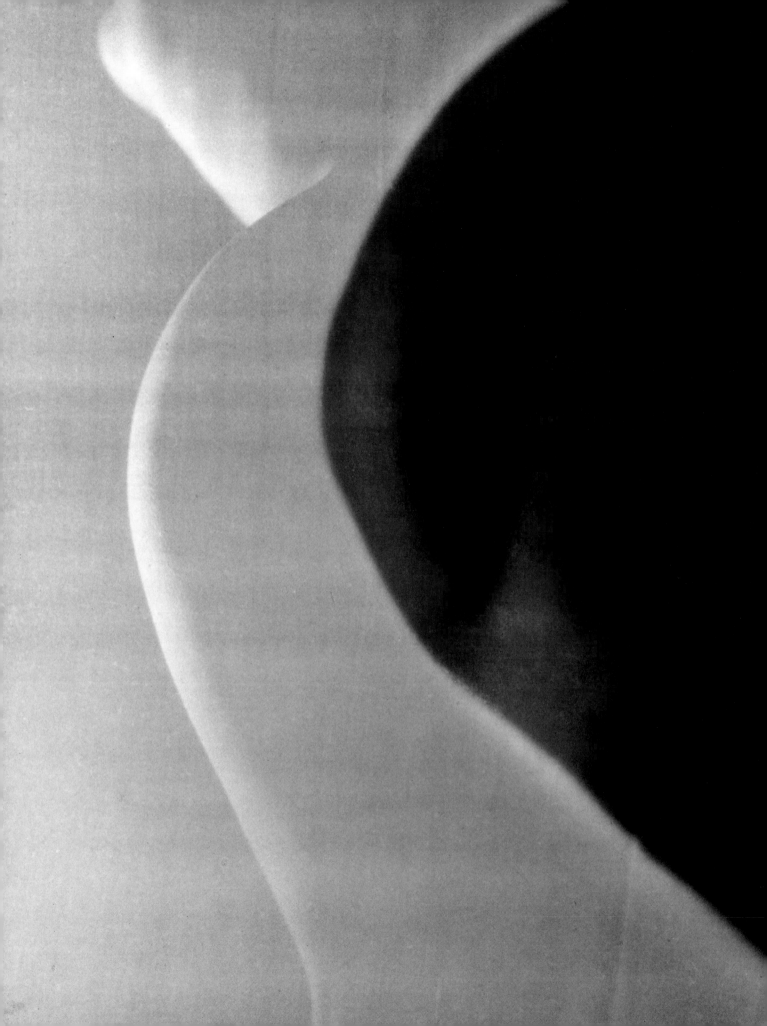

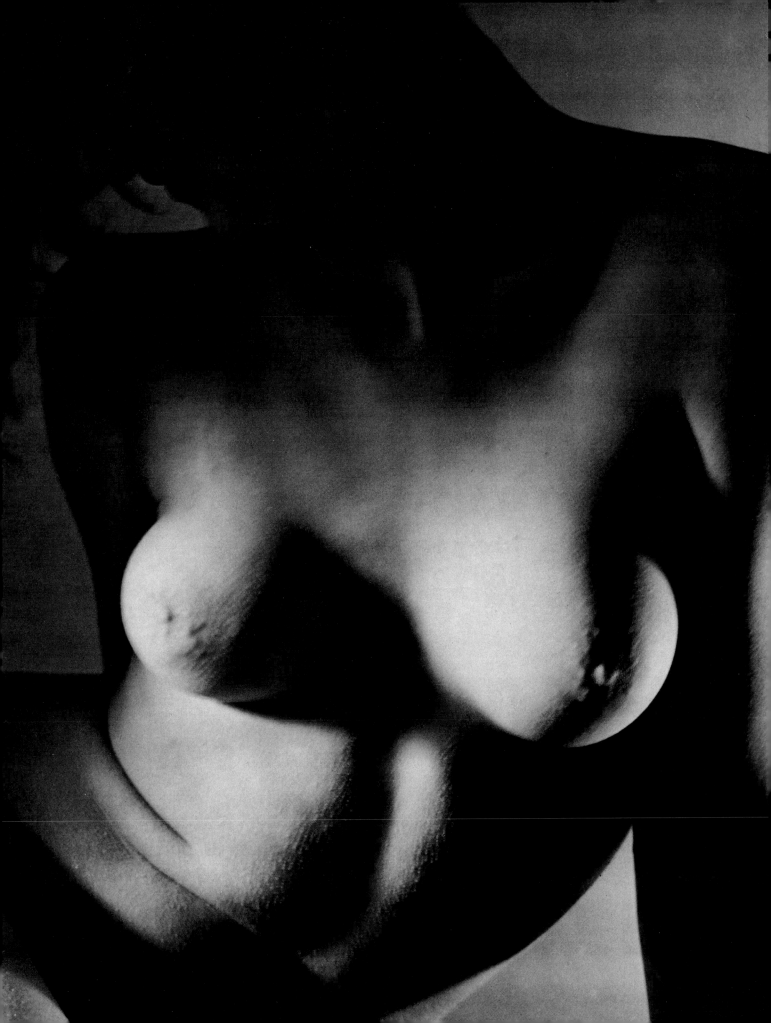

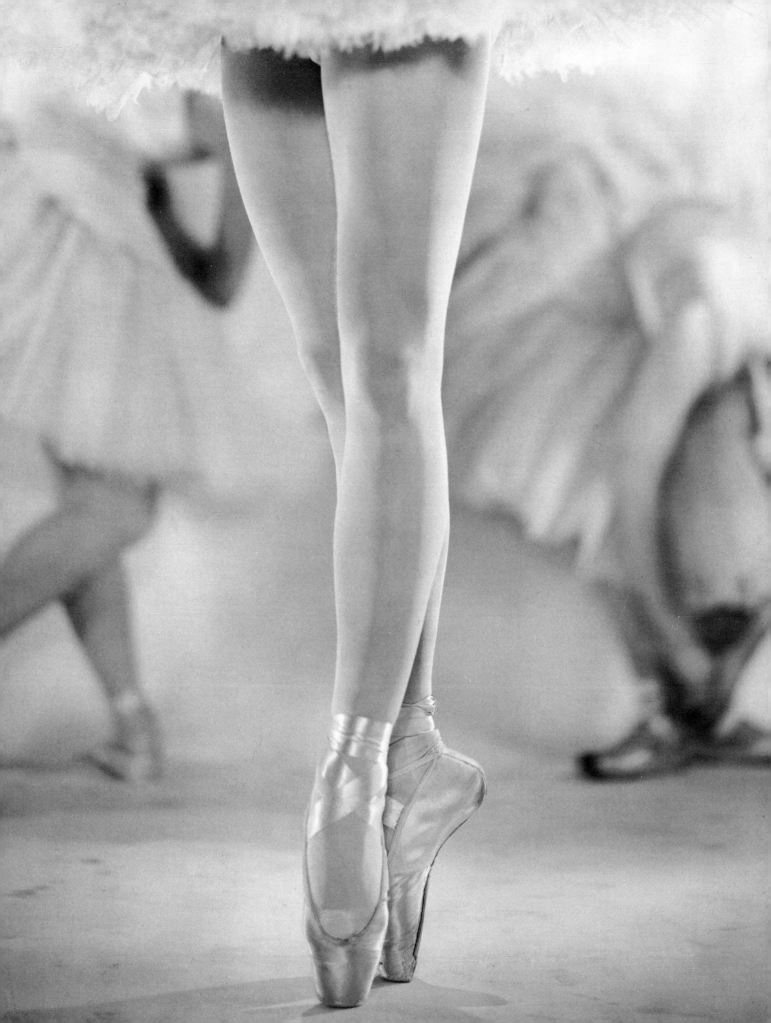

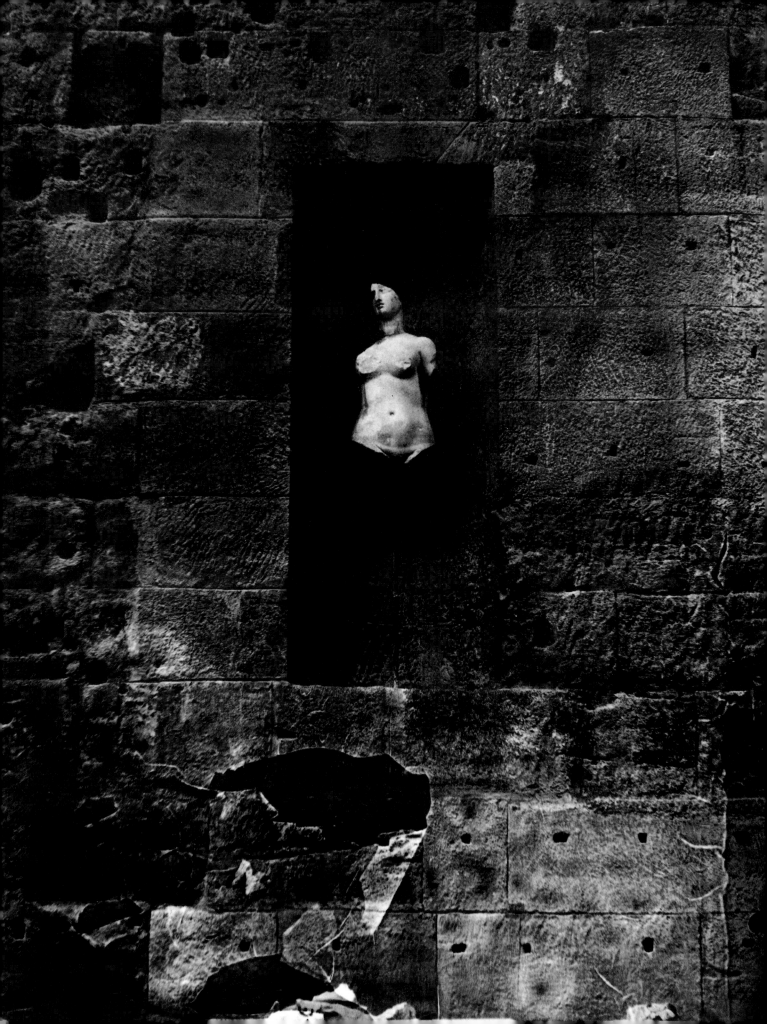

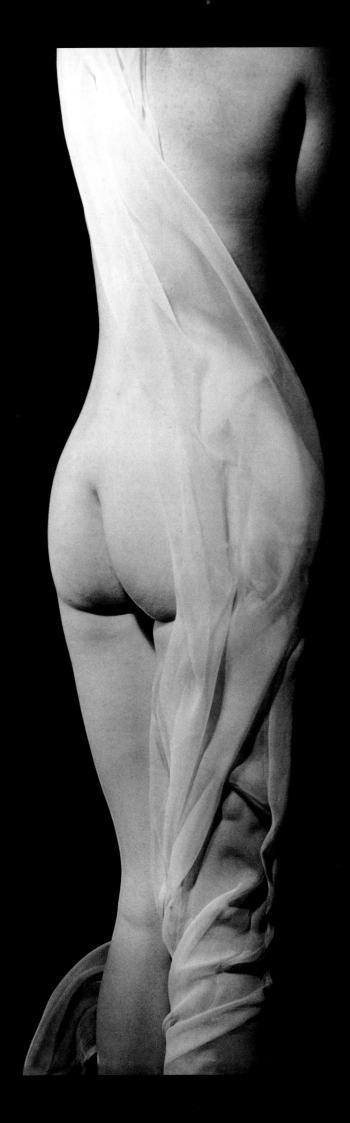

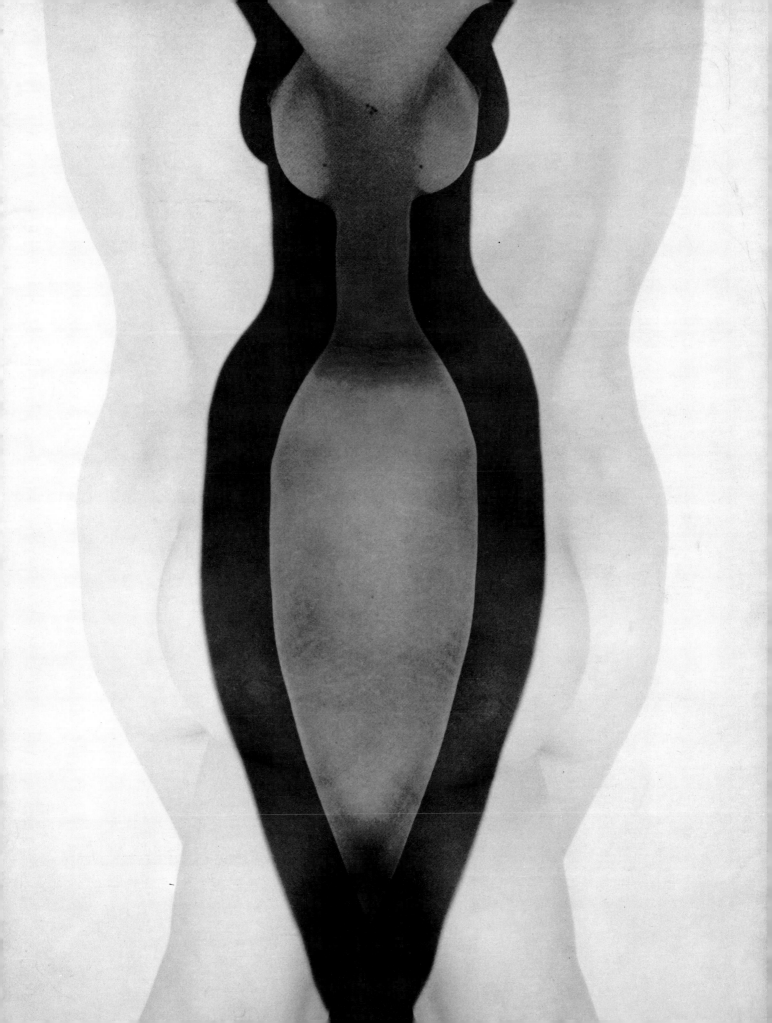

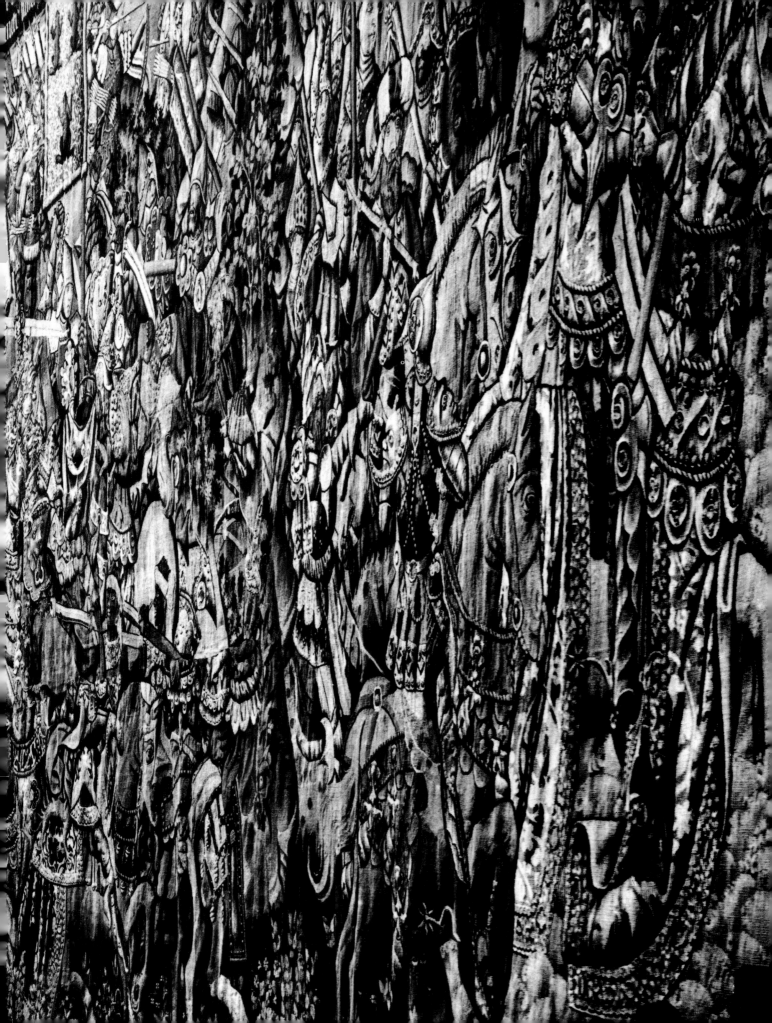

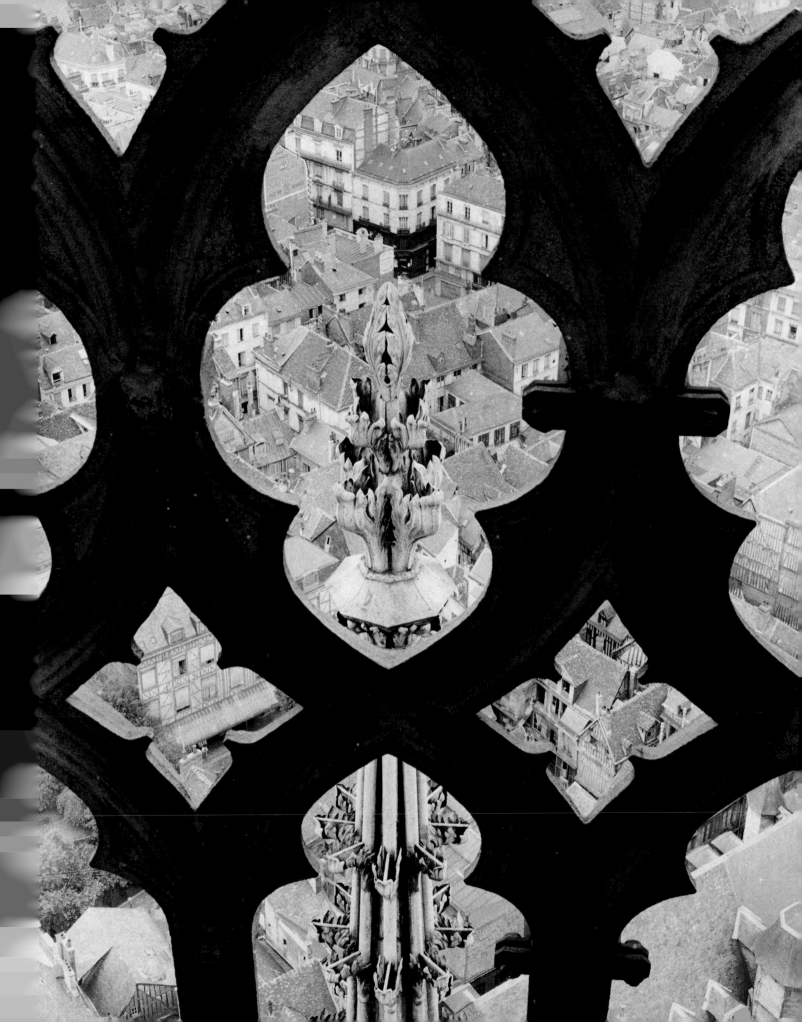

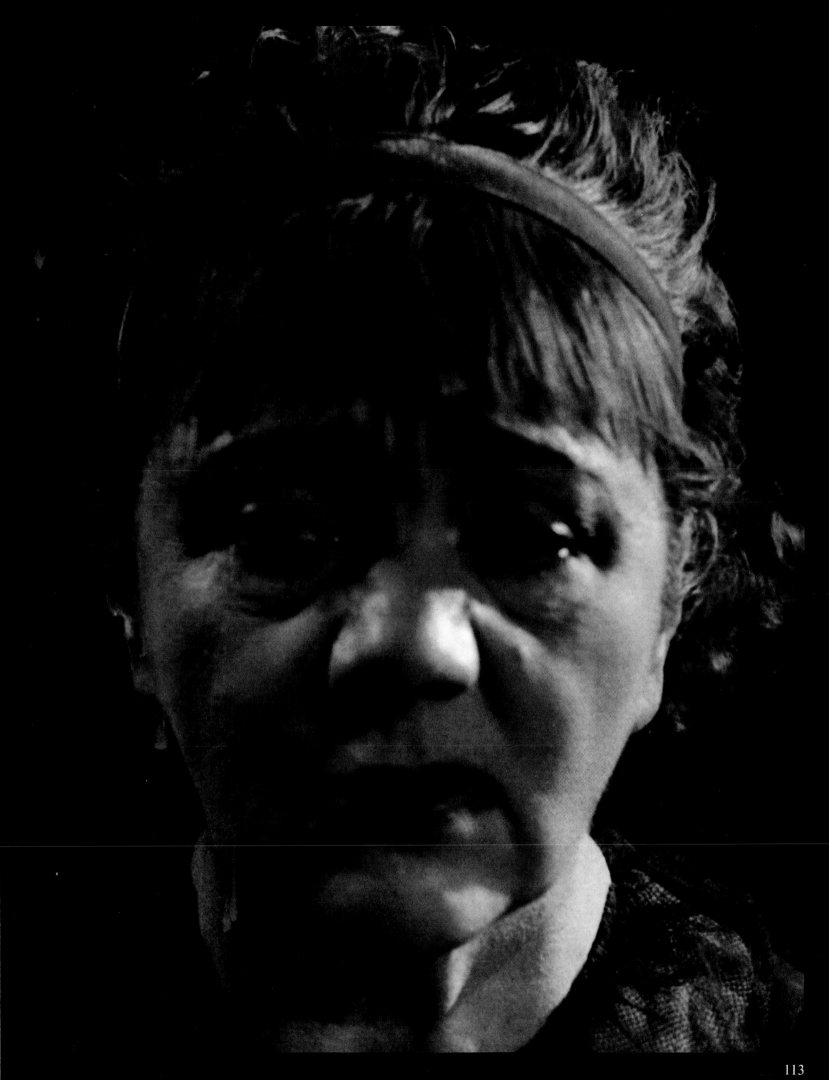

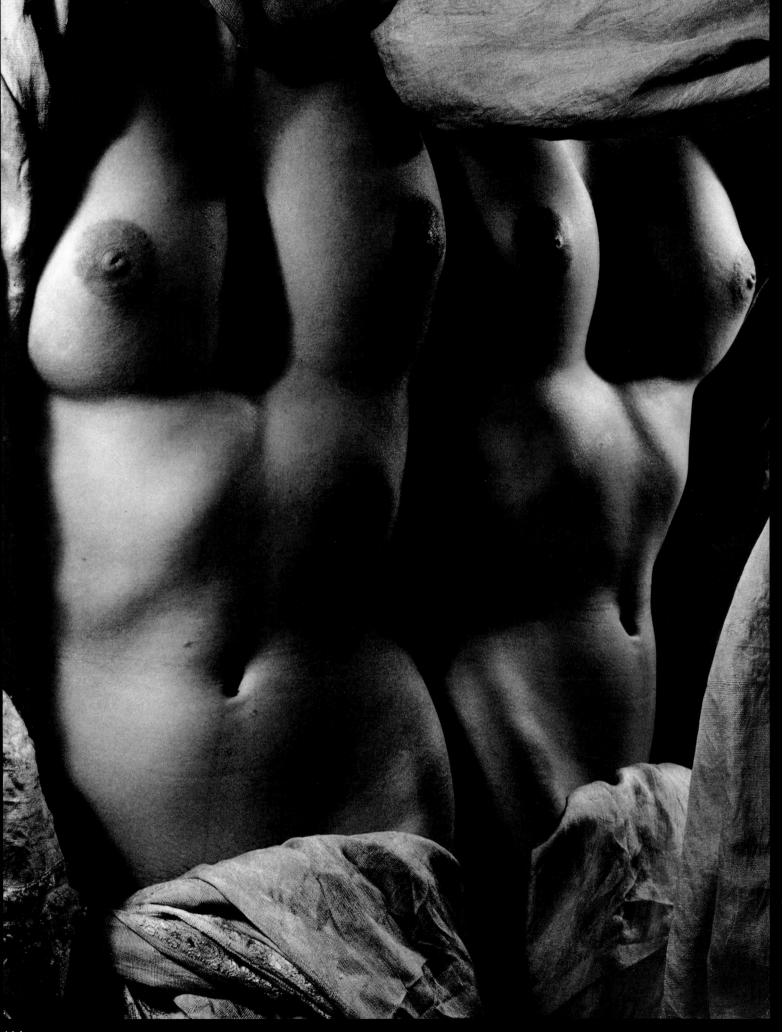

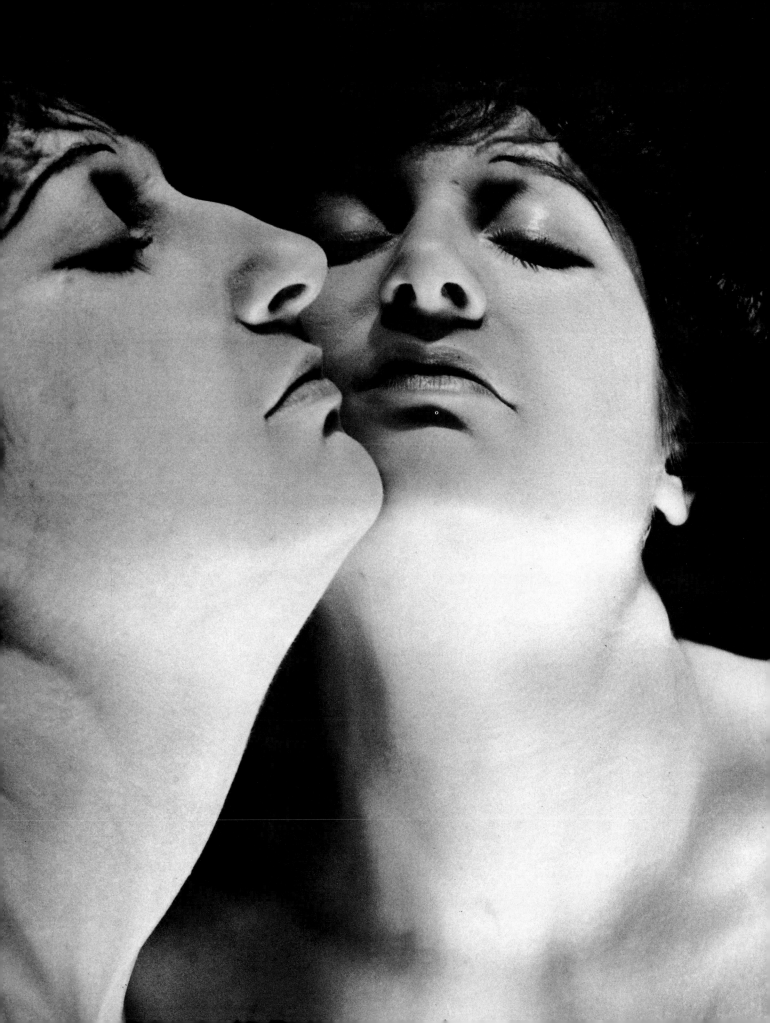

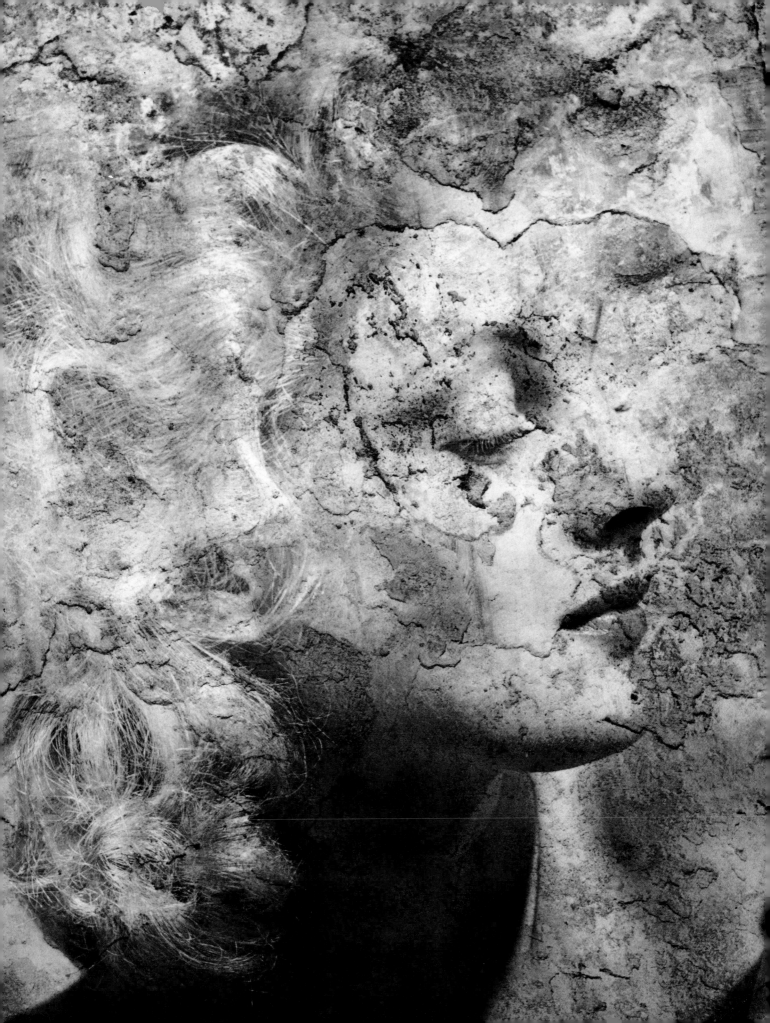

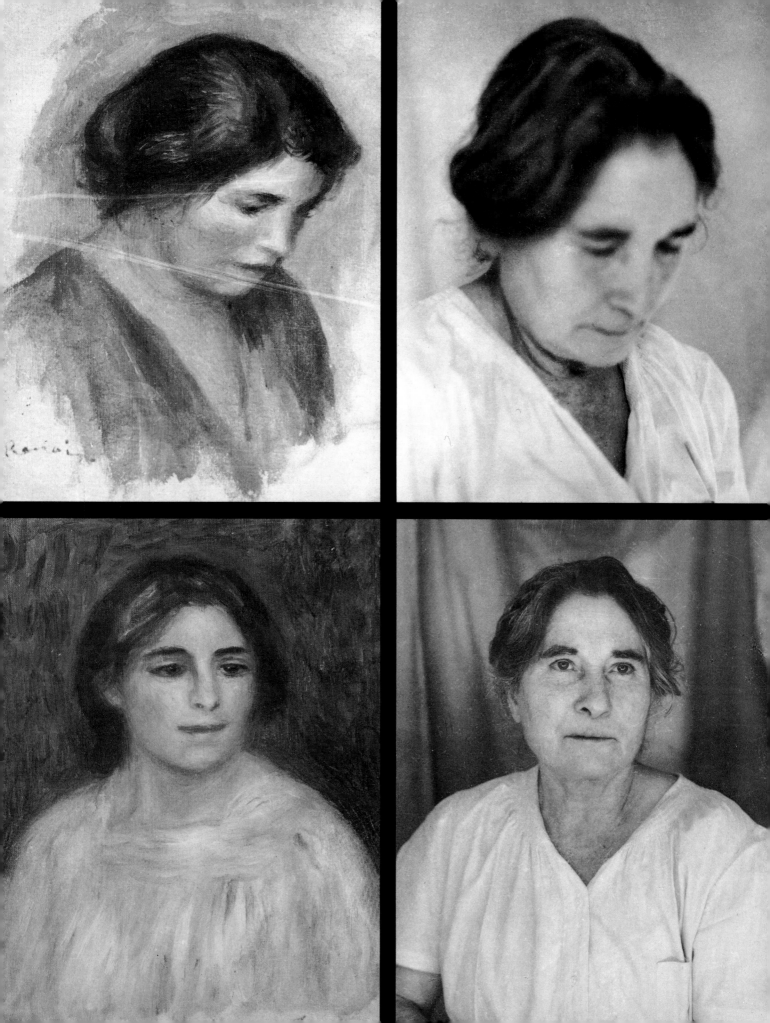

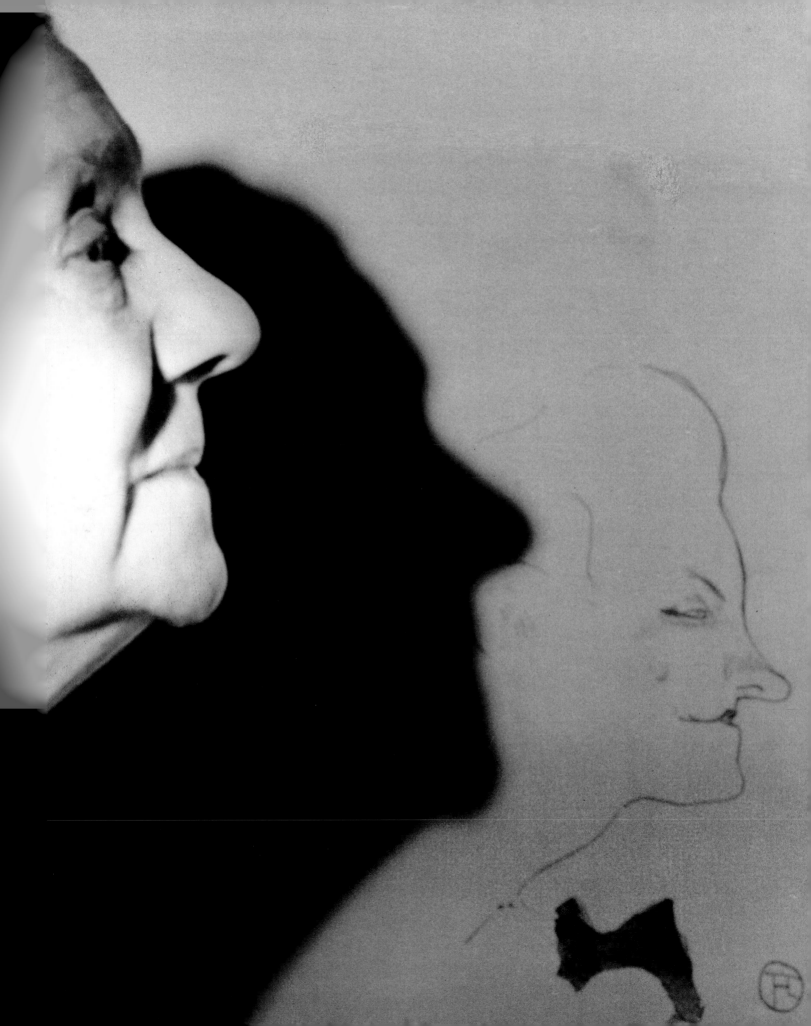

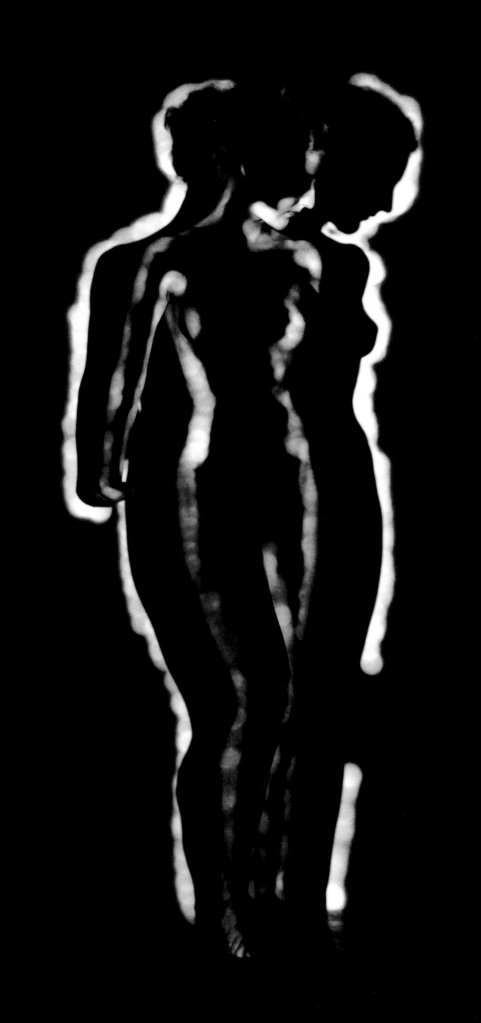

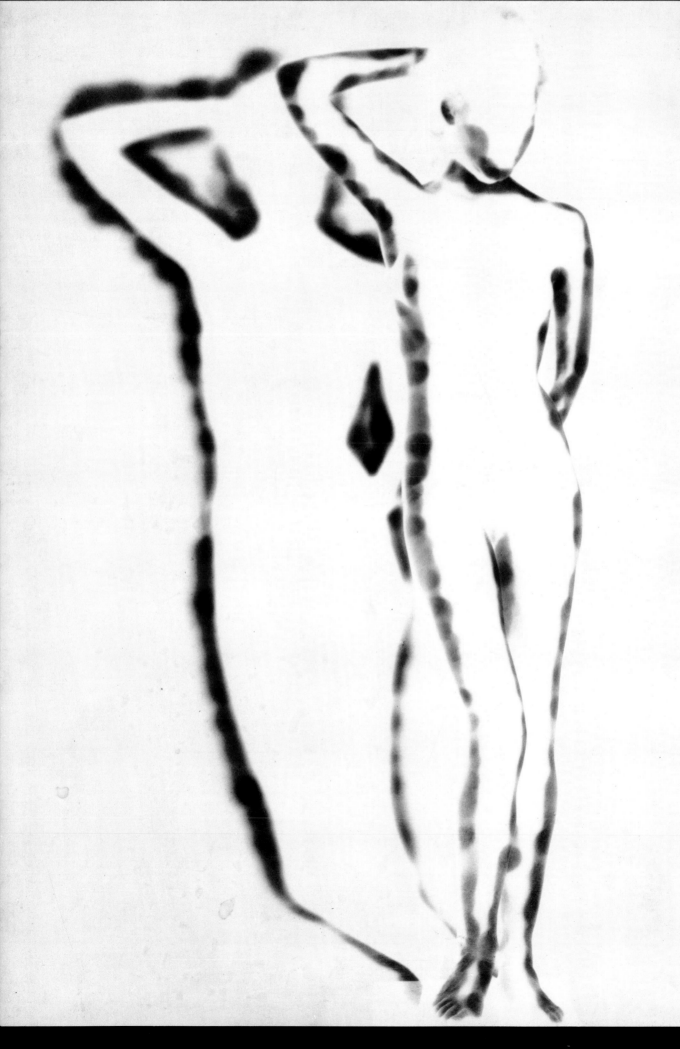

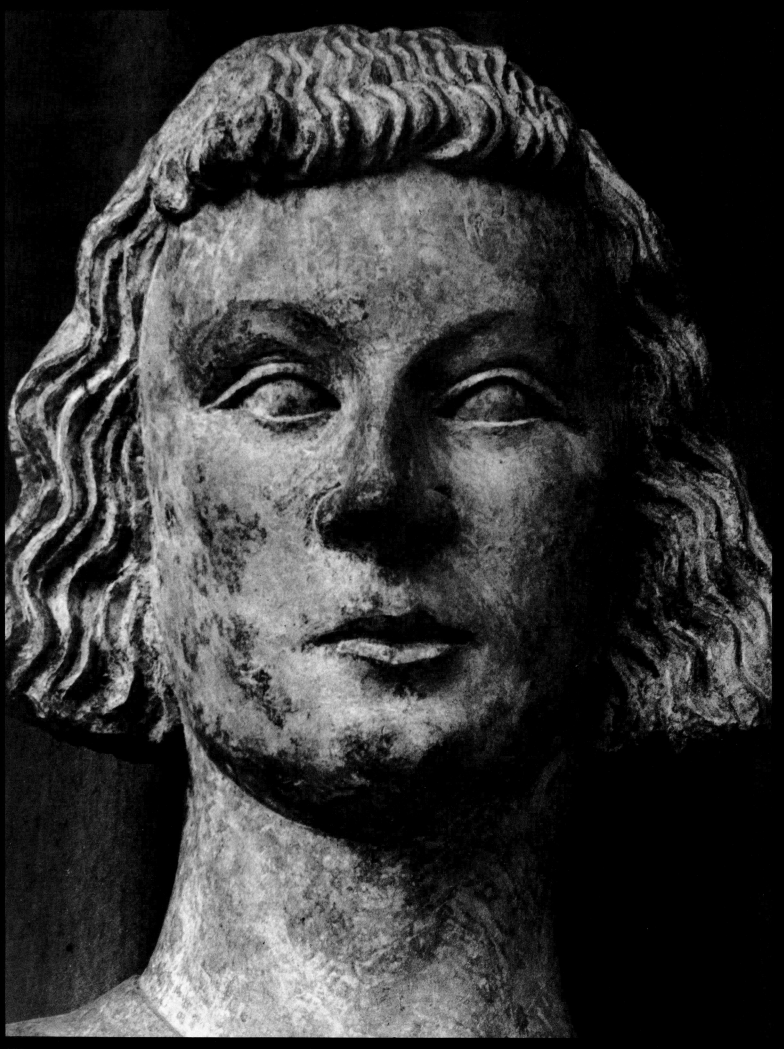

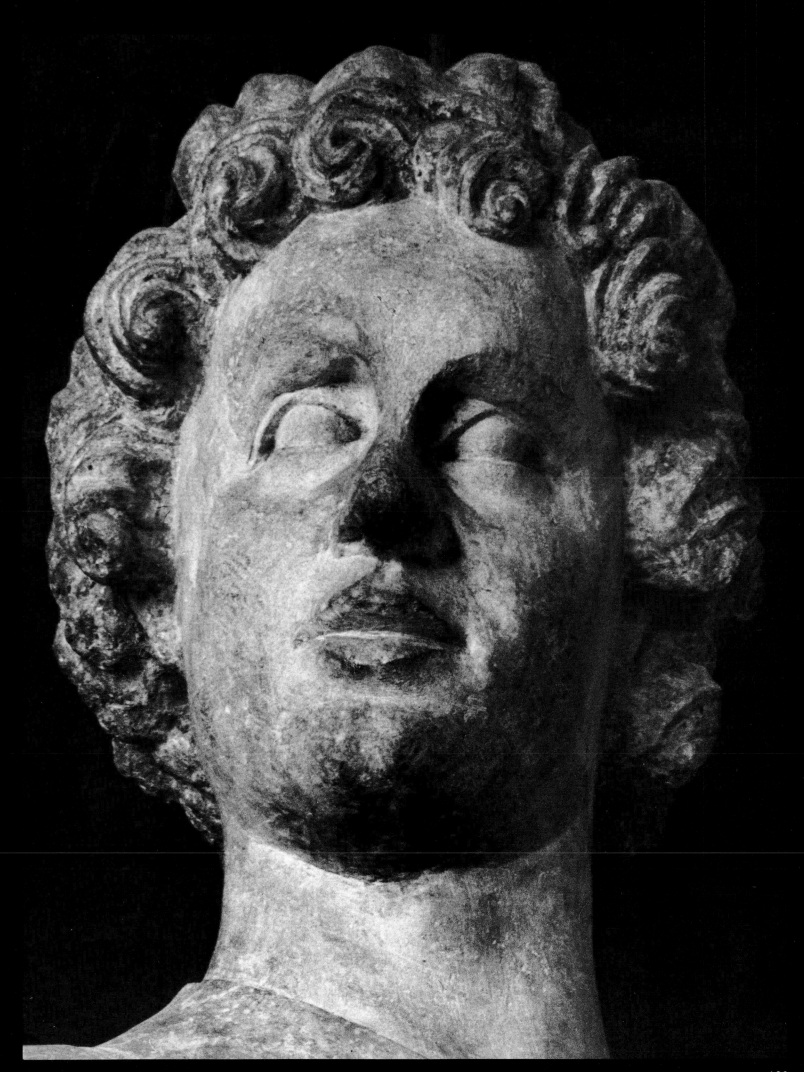

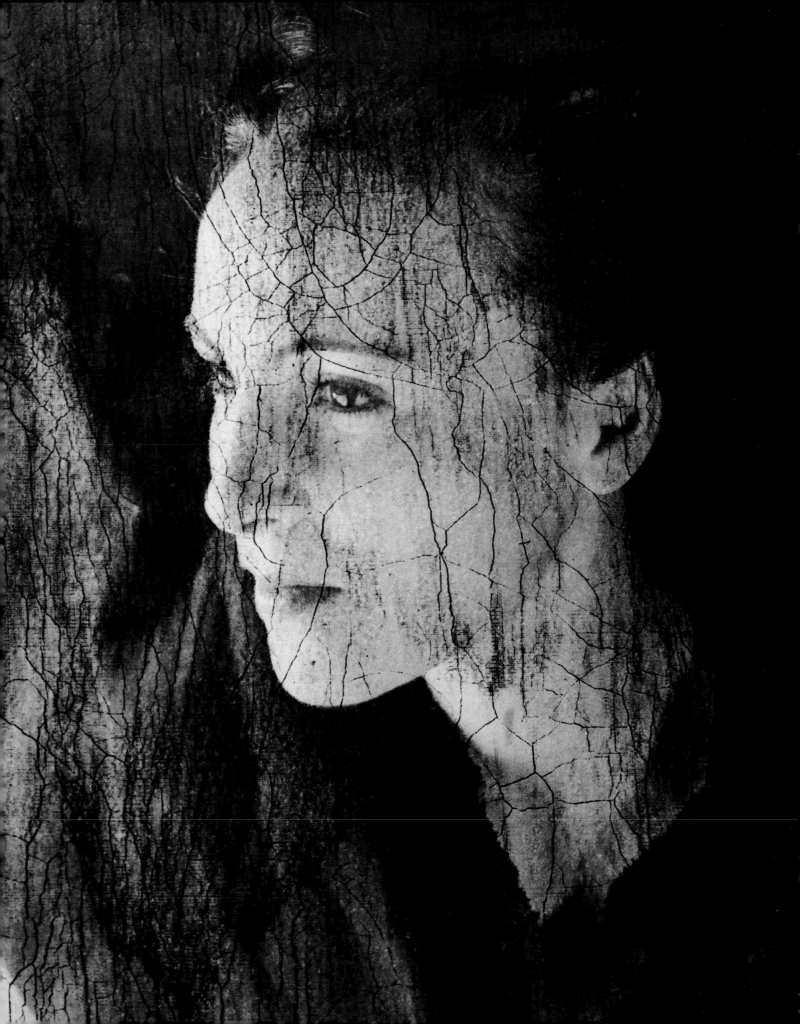

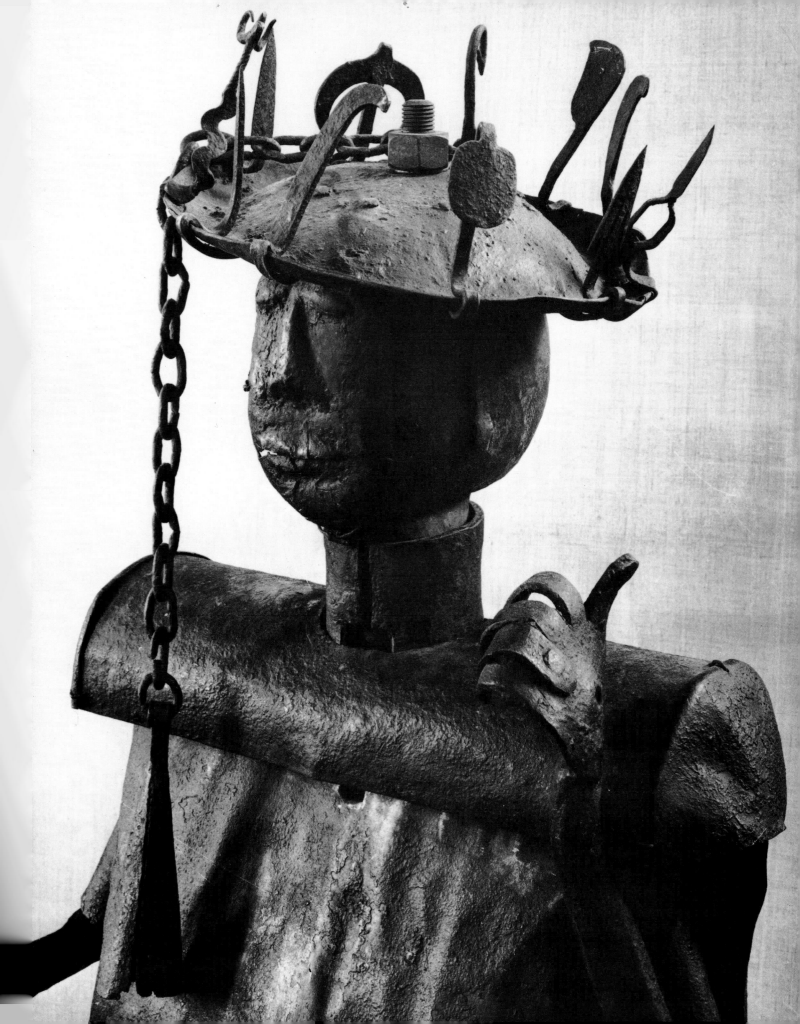

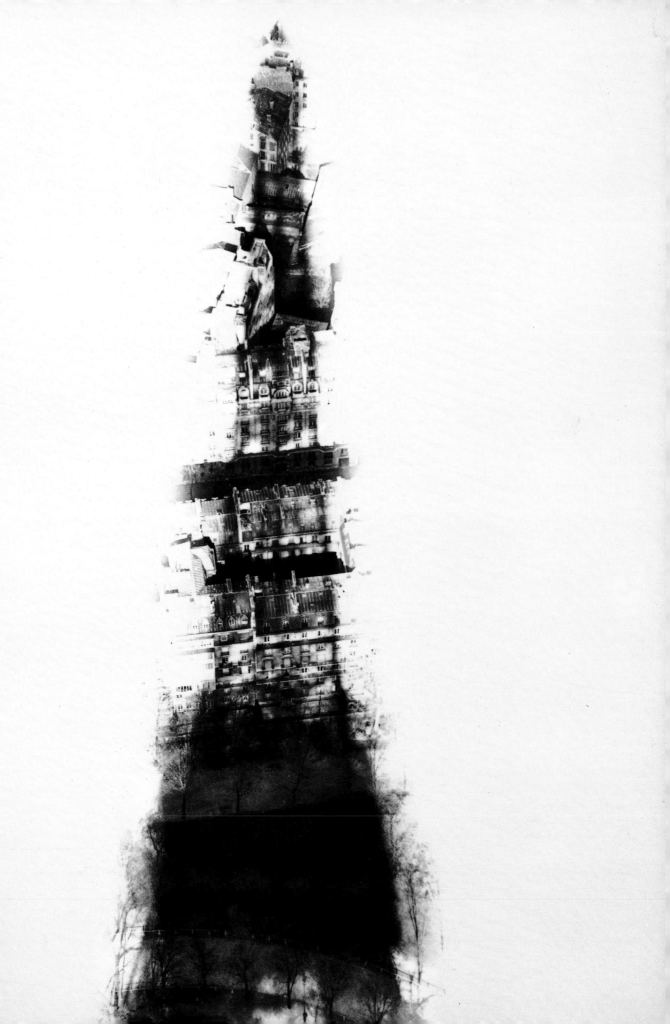

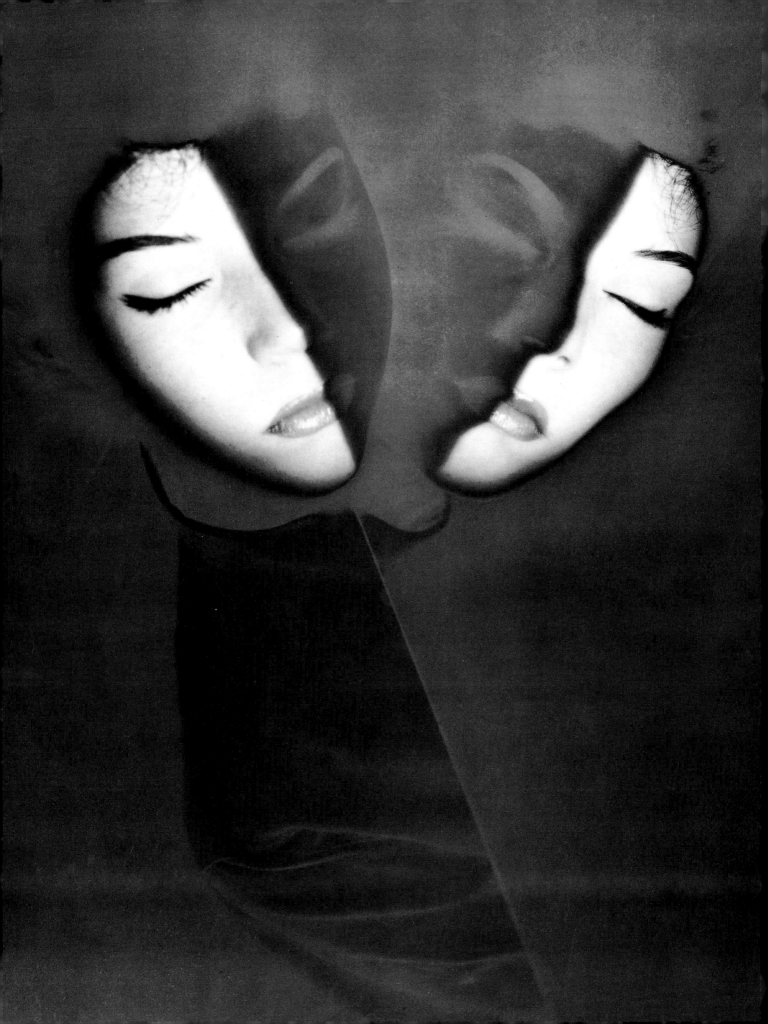

BIOGRAPHY

1897—Erwin Blumenfeld is born on January 26, in Berlin. His mother: Emma Cohn; his father: Albert Blumenfeld; his sister: Annie, born 1894.

1900—Birth of his brother Heinz, who will die in 1918, in World War I.

1913—Secondary school certificate. Death of father. Erwin starts working at the women's fashion store of Moses and Schlochauer.

1916-1918—Ambulance driver for German army.

1918—Exile in Holland. Dada period with Grosz, Mynona, Mehring and Citroen. He paints and writes.

1921—Marriage to Léna Citroen.

1922-35—Owner of a leather goods shop in Kalverstraat, Amsterdam. Amateur photographer and Sunday painter.

1922—Birth of his daughter Lisette

1925—Birth of his son Heinz

1932—Birth of his son Frank Yorick

1935—Bankruptcy of his shop

1936—He leaves Holland and settles in Paris as photographer. First exhibition at Billier's.

1937—Publication of his photographs in the first issue of *Verve* and in the journal *Photo.*

1938—First work for *Vogue.*

1939—First trip to America. Contract with *Harper's Bazaar.*

1940—Return to France. Internment in concentration camps of Montbard-Marmagne, Vernet d'Ariège and Catus.

1941—Emigration to U.S. Sharing of studio of photographer Munkasci.

1943—Opening of his own studio at 222 Central Park South. Great success as photographer. One of the best-paid freelance photographers.

1955—Blumenfeld starts working on his autobiography.

1964—First heart attack.

1969—He dies on July 4 in Rome from a heart attack.

1975—The French translation of his autobiography appears in Paris under the title *Jadis et Daguerre.*

1976—His autobiography appears in German original: *Durch tausendjährige Zeit.*

1979—Exhibition in Geneva at the Rath Museum from January 26 til March 4 of Blumenfeld's *My Hundred Best Photos.* The exhibition is organized by Hendel Teicher.

1980—The exhibition of *My Hundred Best Photos* is shown in London at the Photographers' Gallery from June 5 til July 29.

BIBLIOGRAPHY

1. General Bibliography

Photography

Cecil Beaton and Gail Buckland, *The Magic Image*, Boston, Toronto 1975

Walter Benjamin, *Kleine Geschichte der Photographie* (1931), Frankfurt on Main 1955

Van Deren Coke, *The Painter and the Photograph, from Delacroix to Warhol*, University of New Mexico 1964

Gisèle Freund, *Photographie et société*, Paris 1974

Alexander Libermann, *The Art and Technique of Colour Photography*, New York 1951

Peter Pollack, *The Picture History of Photography*, New York 1969

Aaron Scharf, *Art and Photography*, Baltimore 1968

Malerei und Photographie im Dialog, Zurich 1977

Fashion

Anne-Marie Dardigna, *La Presse "féminine," Fonction idéologique*, Paris 1978

Nancy Hall-Duncan, *Histoire de la photographie de mode*, Paris 1978

Prudence Glynn, *In Fashion, Dress in the Twentieth Century*, London 1978

La Mode, Traverses Nr. 3, Paris 1976

Fashion 1900–1939, London 1975

Art Criticism

Tendenzen der Zwanziger Jahre, Berlin 1977

Fotografie der 30er Jahre, eine Anthologie, Introduction by Hans Jürgen Syberberg, Munich 1977

Emilio Bertonati, *Das experimentelle Photo in Deutschland 1918–1940*, München 1978

foto-auge / oeil et photo / photo-eye, Stuttgart 1929

Dawn Ades, *Photomontage*, London/Paris 1976

Herta Wescher, *Die Geschichte der Collage*, Cologne 1974

Dawn Ades, *Dada and Surrealism Reviewed*, London 1978

Dada, exposition commémorative du cinquantennaire, Zurich 1966 / Paris 1967

Wem gehört die Welt, Kunst und Gesellschaft in der Weimarer Republik, Berlin 1977

Paris–Berlin 1900–1933, Paris 1978

Monographs

Avedon Photographs 1947–1977, New York 1978

Man Ray Photographs 1920–1934, Foreword by A. D. Coleman, New York 1975

Roland Penrose, *Man Ray*, London 1975

Spontaneity and Style, Munkasci, a Retrospective, New York 1978

2. Erwin Blumenfeld

Photographs 1936–1939

Photo, Arts et Métiers graphiques, Paris (1936–1939)

Verve (December 1937, March–June 1938)

Vogue, Paris (1938–1939)

1941–1955

Vogue (1941–1955)

Harper's Bazaar (1941–1955)

Look (1941–1955)

Cosmopolitan (1941–1955)

Life (October 1942)

Popular Photography (October 1944)

Graphis, Zurich (Nr. 15, 1946)

Picture Post, London (December 1946; February 1947; June 1947)

A number of photographs have recently appeared, mainly in: *Zoom*, Paris, May-June 1975; *Photo*, Paris, November 1975, April 1977; *Modern Photography*, New York, 1976; *Du*, Zurich, April 1978

Writings

Jadis et Daguerre, Paris 1975 (Translation from the German) Robert Laffont, Paris

Durch tausendjährige Zeit, Frauenfeld 1976 (German edition)

The numerous poems and prose pieces which Blumenfeld wrote before the war—and were mostly not published—have all disappeared, except for one: *Atze lenzgedicht* in *Almanach Dada*, Berlin, 1920

Meine 100 Besten Fotos, Benteli Verlag, Bern 1979

Exhibitions

1936 Billier, Paris

1975 FNAC-Montparnasse, Paris, April/May

1978 Witkin Gallery, New York, March/April

Galerie Zabriskie, Paris, November-January 1979

1979 Rath Museum, Geneva, January-March

1980 Photographers Gallery, London, June-July